Drawing Techniques

PENCIL, CHARCOAL, AND INK

Giovanni Civardi

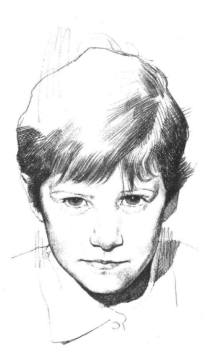

SEARCH PRESS

First published in Great Britain 2002 by Search Press Limited,
Wellwood, North Farm Road, Tunbridge Wells, Kent TN2 3DR

Reprinted 2006 (twice), 2007

Originally published in Italy 1992 by Il Castello Collane Tecniche,
Milano

Copyright © Il Castello Collane Tecniche, Milano 1992

English translation by Julie Carbonara

English translation copyright © Search Press Limited 2002

ISBN 10: 1 903975 08 5
ISBN 13: 978 1 903975 08 4
Design by Grazia Cortese

Printed in Malaysia

INTRODUCTION

Drawing was one of the first means of expression and representation invented by man, when he drew on the walls of prehistoric caves, and it is still extremely valid, both as an artistic representation of reality and as a means of expressing pure imagination.

To be able to draw means, above all, to be able to 'see', to understand rationally, to feel emotions, and to master the techniques which allow us to fully express our thoughts and moods.

This book focuses on the main drawing media, because technique at least can be learnt through experimentation, practice and constant application. There are plenty of manuals which deal extensively with drawing materials and how to use them, but my teaching experience has taught me that, initially, those who are new to drawing need, above all, information, comprehensive and simplified, on the most common media and on the results which can be achieved with each. Personal choices and mastering the subject can come later, when necessary, as there is no point in anticipating ideas or making suggestions which would not be acted upon or, worse, could dishearten if given too soon.

The drawings collected here represent different periods in my career and should not be taken as examples of a drawing style to imitate, but simply as an indication of the purely technical results which can be achieved with the various graphic media. Moreover, they are all of a highly figurative nature – many decidedly academic – as it is easier, and more useful, to begin learning to draw from life. But don't stop here: as soon as you feel comfortable with the various media and how to use them, try to go beyond reality; that is, use them as a source of inspiration and stimulation which will put you in touch with your deepest feelings, and then communicate them by drawing. Bear in mind that, for the true artist, technique is indeed essential but only as a tool which, once mastered, must adapt to and serve your expressive needs.

MATERIALS AND EQUIPMENT

The materials and equipment used for drawing today are, essentially, those which have been used traditionally for centuries: pencils, pens, brushes, inks, papers, etc. The diagram below features those which are indispensable when first starting to draw.

Drawing paper comes in many types, colours and qualities, each with distinctive characteristics which make it more or less suited to the different media techniques (e.g. charcoal needs a rough surface, while pen flows more easily on smooth paper). To see the effect of different media on different surfaces, experiment with some of the examples opposite.

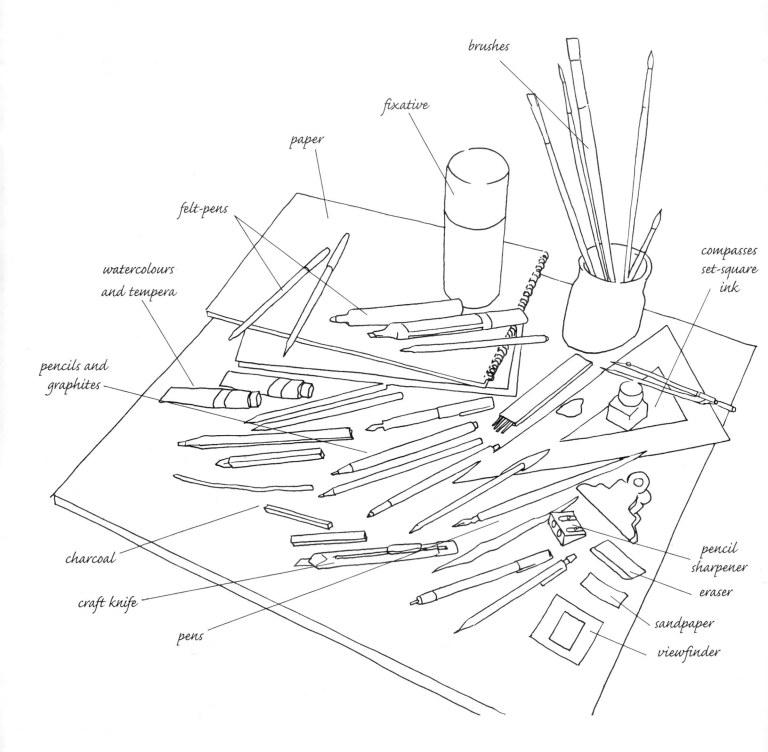

brushes

fixative

paper

felt-pens

watercolours
and tempera

compasses
set-square
ink

pencils and
graphites

pencil
sharpener

charcoal

eraser

craft knife

sandpaper

pens

viewfinder

STROKES DRAWN ON SMOOTH PAPER WITH DIFFERENT MEDIA

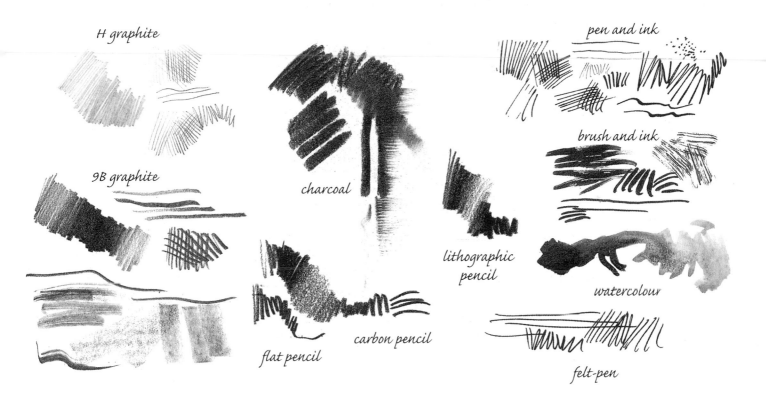

H graphite

pen and ink

9B graphite

charcoal

brush and ink

lithographic
pencil

watercolour

flat pencil

carbon pencil

felt-pen

STROKES DRAWN ON ROUGH PAPER WITH DIFFERENT MEDIA

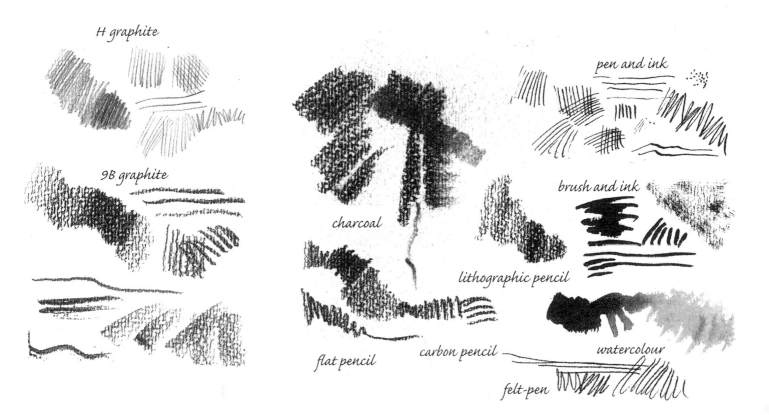

H graphite

pen and ink

9B graphite

charcoal

brush and ink

lithographic pencil

flat pencil

carbon pencil

watercolour

felt-pen

BASIC TECHNIQUES

THREE-STAGE MODEL

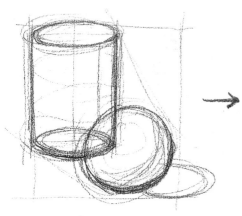 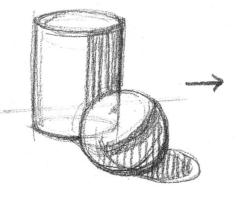 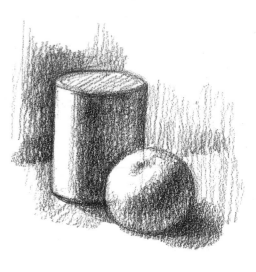

Stage 1 Suggest the relative proportions of the objects.

Stage 2 Determine the shapes, tracing the contours of the shaded areas.

Stage 3 Complete the form, emphasising tonal values.

TONES

Tonal gradations (light-dark) can be achieved in different ways: by varying the pressure (examples A and B); by cross-hatching (example C) and by dilution (example D).

A 2B pencil

B Compressed charcoal

C Pen and ink

D Water-soluble ink

LIGHT AND SHADOW

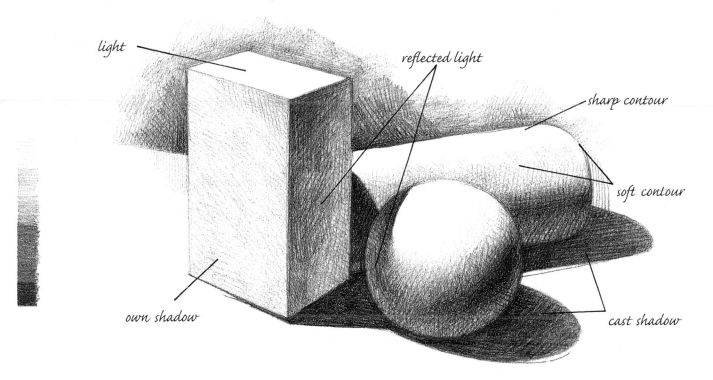

light

reflected light

sharp contour

soft contour

own shadow

cast shadow

LINE AND TONE

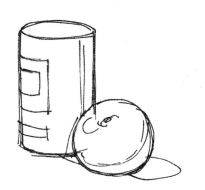

linear drawing

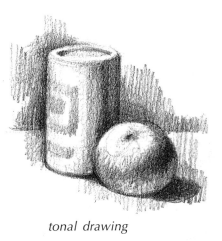

tonal drawing

CREATING TONES WITH HATCHING, CROSS-HATCHING AND OTHER TECHNIQUES

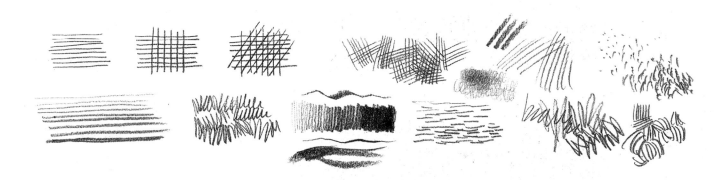

PENCIL AND GRAPHITE

Pencil is the most widely-used drawing medium as it is cheap and versatile. Besides the traditional wood-encased pencils, there are other types of pencils: graphites or leads (thin sticks, held in mechanical clutch pencils); waxy, lithographic pencils; water-soluble pencils; flat, carpenter's pencils; and very thin (micro) leads, held in propelling pencils.

Graphites are graded in a decreasing scale from 9H (the hardest) to H, and in an increasing scale from B to 6B (the softest). Beyond this grade (up to 9B) graphites are made in thick sticks for easier handling. HB is the medium grade, neither too hard nor too soft. Hard graphites, also called 'technical' leads, draw faint, clean, even lines, while the soft types are more 'artistic' and accurately represent the different levels of pressure in freehand drawing. A drawing's dark tones can be achieved either by increasing the graphite's pressure on the paper, or by drawing increasingly close lines over one another at right angles (cross-hatching). Tones can be blended into one another by smudging with a finger, with a wad of cotton wool or with a rolled paper stump.

EXAMPLES ON MEDIUM-TEXTURED CARD

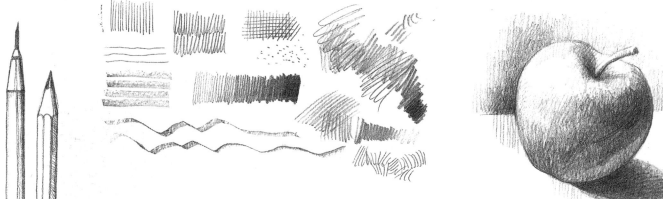
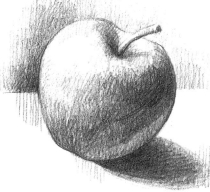

2H hard pencil or graphite

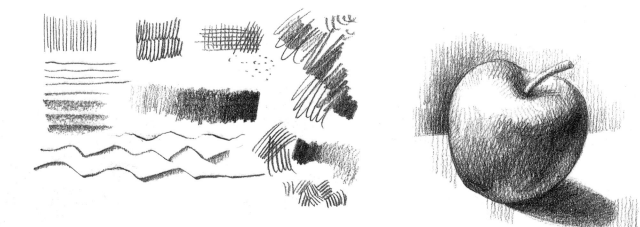

HB medium pencil or graphite

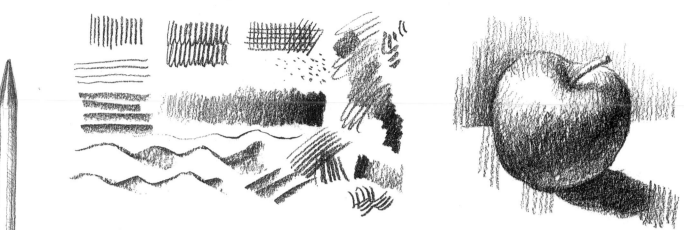

6B soft graphite

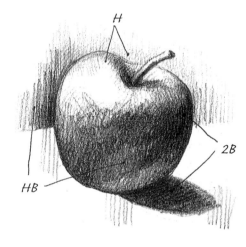

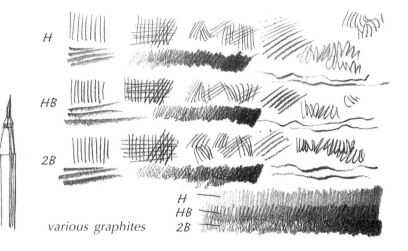

various graphites

H
HB
2B

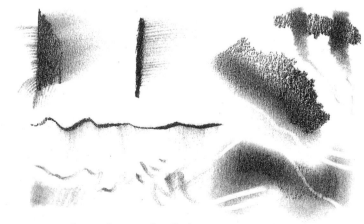

9B soft graphite and rolled paper stump

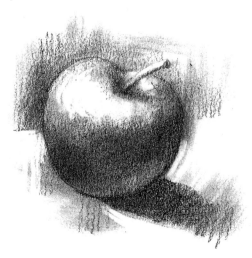

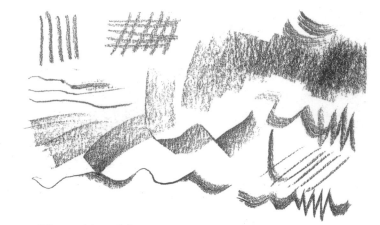

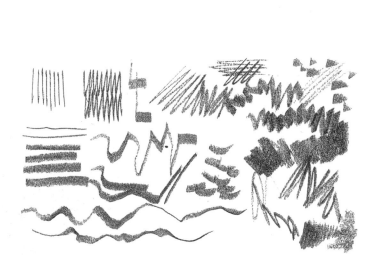

2B graphite stick

flat pencil

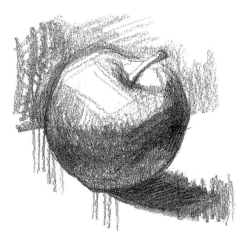

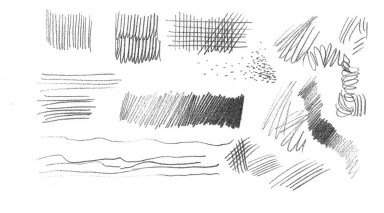

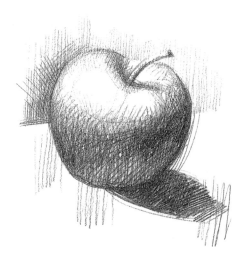

very fine lead

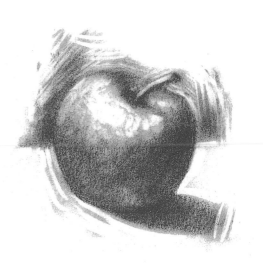

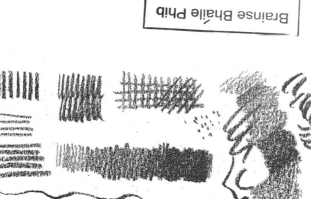

graphite dust and highlights added with an eraser

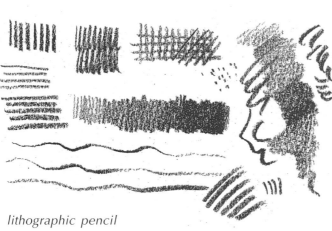

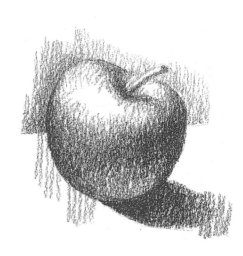

lithographic pencil

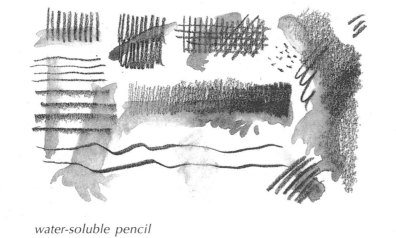

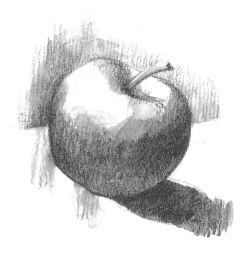

water-soluble pencil

The drawings shown on this page and the next are two portrait studies. They have been done from life on fairly smooth paper, 42 x 56cm (16½ x 22in), using 2H pencil. Both drawings are fairly linear and a faint tonal grading has been achieved with a more or less intense and regular cross-hatching. The hard pencil (which I have kept well sharpened) has enabled me to complete the drawings in quite a pale tone showing little contrast, and made more intense by using increased pressure in places.

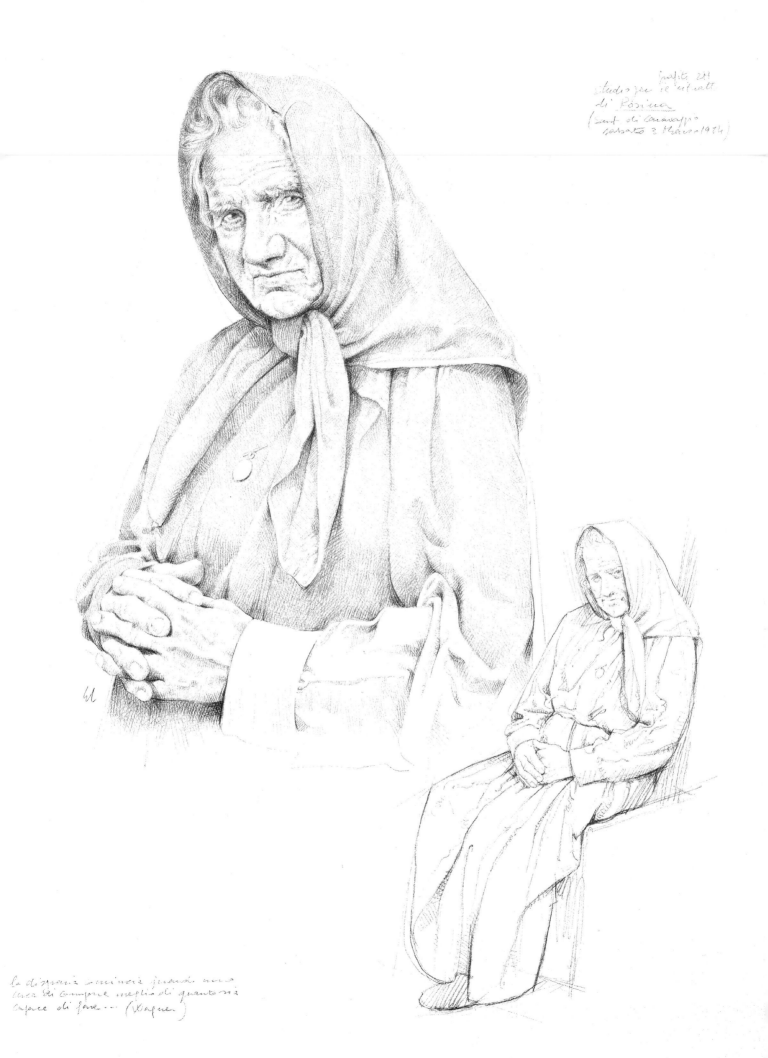

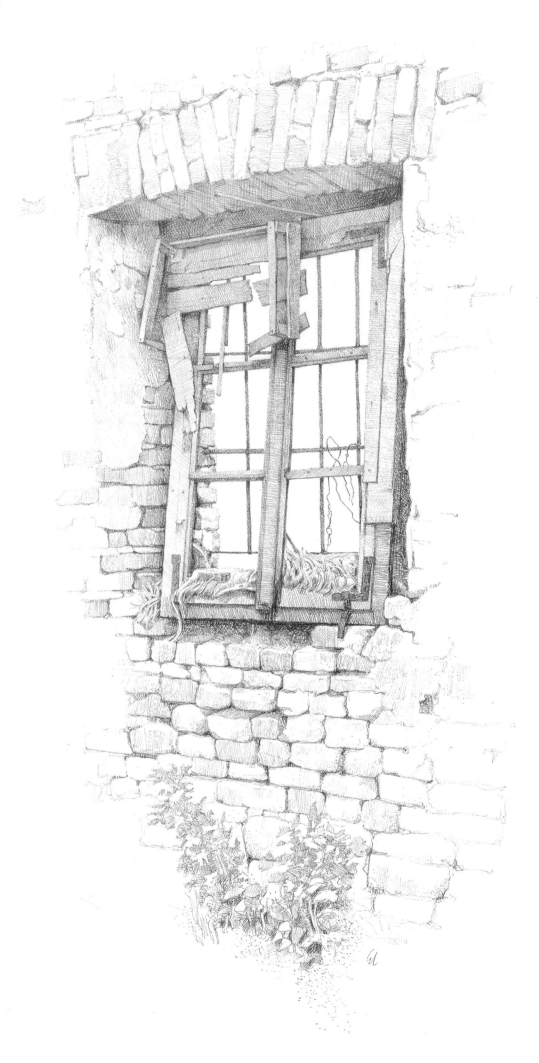

H and 2H pencil on paper, 40 x 50cm (16 x 19½ in). This is a study for an etching. The cross-hatching, with its even strokes, mimics the traditional etching process, and helped me solve some tonal and compositional problems before tackling the copper plate. Its size is, of course, much smaller: 20 x 30cm (8 x 12in). Dotting can be used as well as hatching, as you can see at the base of the wall.

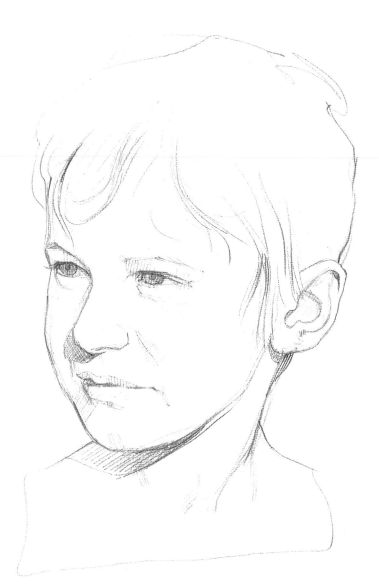

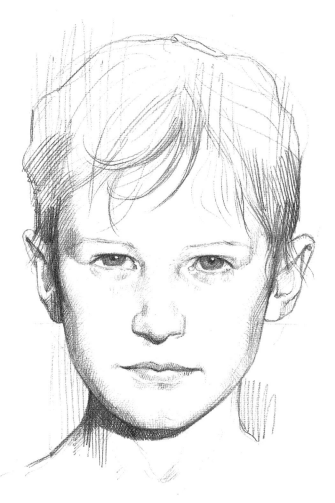

When commissioned to draw a portrait, I start by studying the appearance of the model. Above all, however, I study the model's character in order to understand whether the work holds some sort of human, as well as aesthetic, interest for me. The drawings on this page show how I proceed, at least initially. Some sketches are accurate; some rough and intuitive and done in a few minutes to catch the structure of the face, the attitude or the expression, the composition, and in the main ignoring chiaroscuro (the contrast between light and dark) effects. I have used HB pencil on two sheets of rough Fabriano paper, 33 x 43cm (13 x 17in).

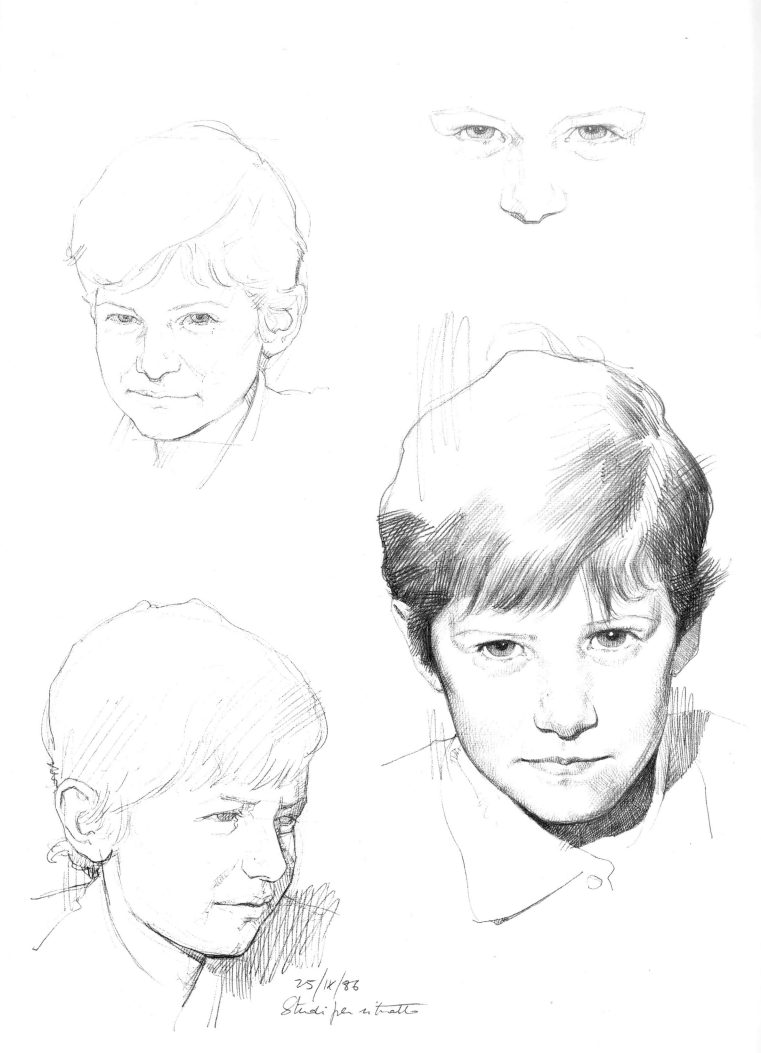

25/IX/86
Studi per ritratto

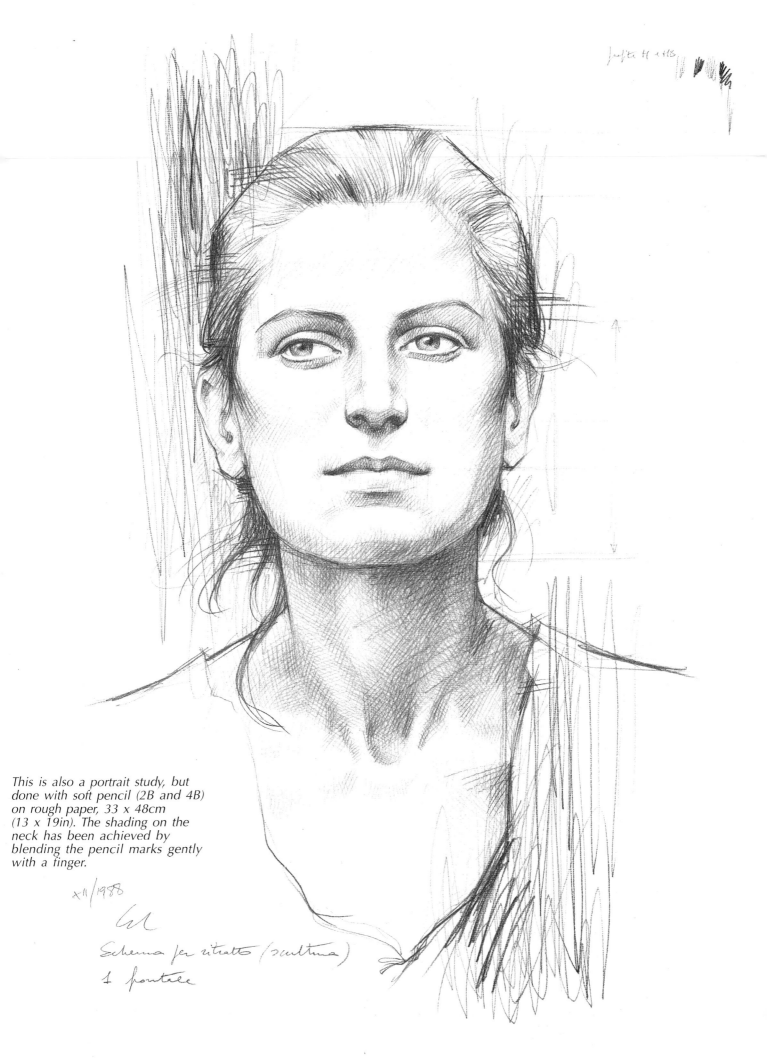

This is also a portrait study, but done with soft pencil (2B and 4B) on rough paper, 33 x 48cm (13 x 19in). The shading on the neck has been achieved by blending the pencil marks gently with a finger.

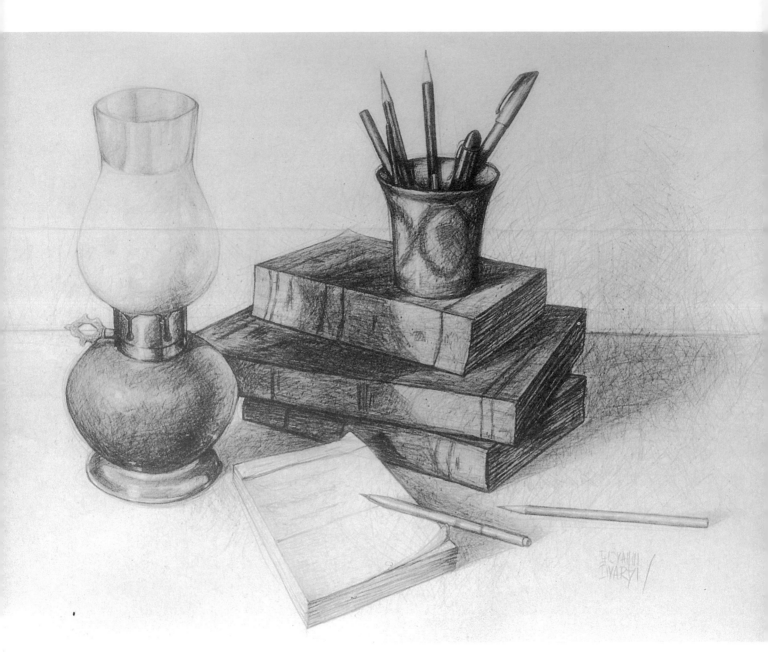

HB, 2B and 4B pencil on paper, 50 x 70cm (19½ x 27½ in).
'Lamp and books' and 'Tools', the two drawings shown on
these pages are examples of the type of exercises you do
early on in art school. Their aim is to train students to observe
reality and give them the opportunity to tackle simple
problems of composition, perspective and chiaroscuro. Both
drawings have been done by placing the paper vertically on
the easel and 'giving shape' to the objects by using light, but
irregular and fairly intense, cross-hatching. The monotony of
some areas has been achieved by dotting, in this case by
striking the sheet hard with the point of a soft pencil.

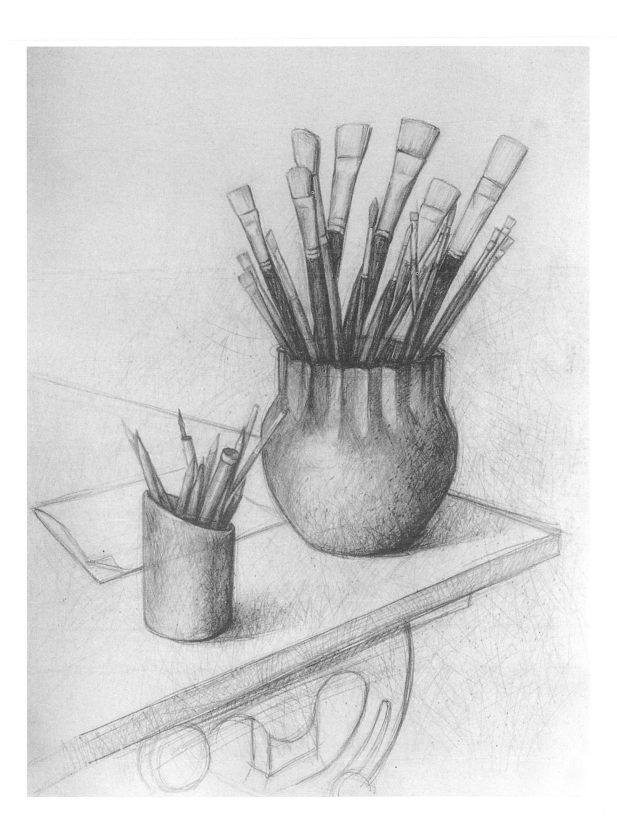

'Drapery', 2B and 6B pencil on paper, 50 x 70cm (19½ x 27½ in). Like the two previous drawings, this is a scholastic study. To achieve a 'sculptural' effect I have emphasised the 'structure' of the folds, rather than the softness of the fabric, highlighting the more significant ones and ignoring those which are not essential. The pencil has been smudged gently over the whole drawing with a wad of cotton, and a kneadable putty eraser has been used to pick out lit areas and highlights.

The soft graphite stick (6B) used
for this drawing allows loose
strokes and avoids minute detail.
The smooth surface only partly
holds the graphite: for this reason
the marks lack intensity and
strong pressure is needed to
achieve darker accents.

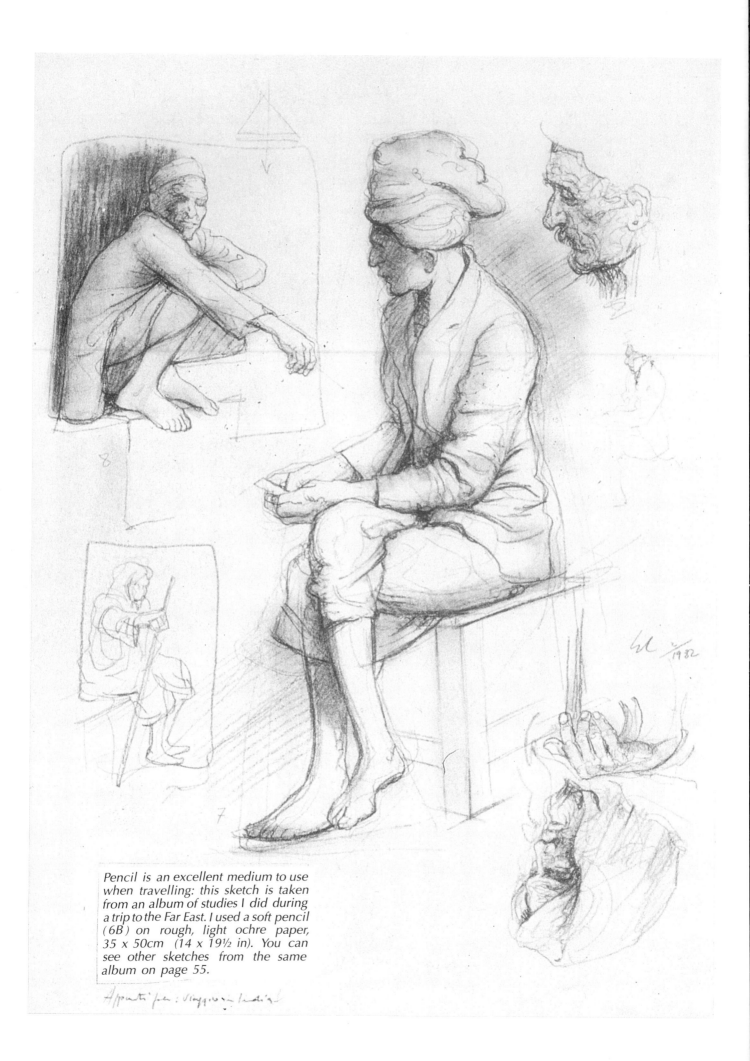

Pencil is an excellent medium to use when travelling: this sketch is taken from an album of studies I did during a trip to the Far East. I used a soft pencil (6B) on rough, light ochre paper, 35 x 50cm (14 x 19½ in). You can see other sketches from the same album on page 55.

As many of my paintings and sculptures are portraits, my examples deal mainly with drawing the human body. The one shown here has been drawn with a lithographic pencil, by cross-hatching and varying the pressure, on hand-made paper, 50 x 70cm (19½ x 27½ in). To avoid placing my hand on the sheet, I used a thin wooden board as a bridge.

CHARCOAL, CHALK AND CARBON PENCIL

Willow charcoal is made by charring small twigs of willow: it is soft and leaves a dusty residue. Compressed charcoal (in stick or pencil form) is made from compressed coal dust and will give deep black strokes. Charcoal is ideal for fast, immediate drawings, with strong tonal contrast, but is less suitable for achieving minute detail. Smudging charcoal is even easier than graphite and the same methods are used, but be careful not to overdo it as you risk ending up with a drawing which lacks power, is photographic and structurally weak. Instead, it can be better to use a kneadable putty eraser to lighten or vary tones and 'carve' the lights. A type of charcoal often used for figure and landscape studies is 'sanguine', which has a particularly bright and warm colour.

EXAMPLES ON MEDIUM-TEXTURED CARD

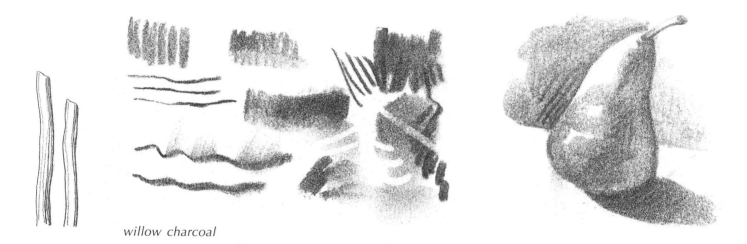

willow charcoal

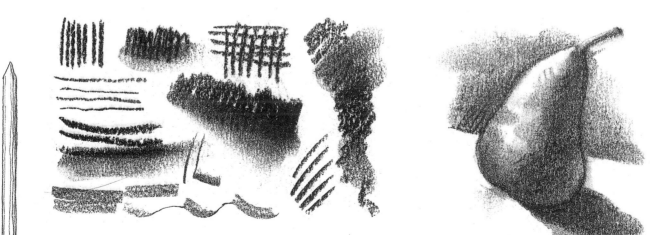

compressed charcoal

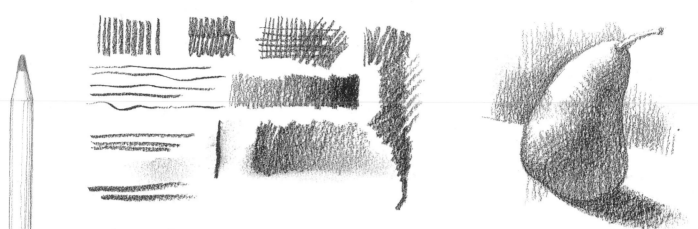

carbon pencil

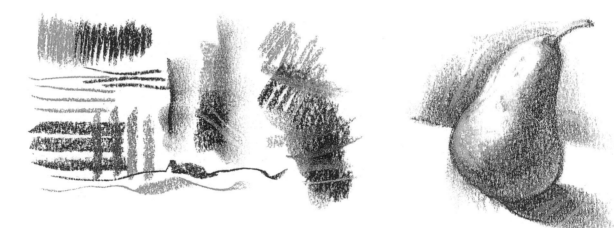

black, grey and white chalk

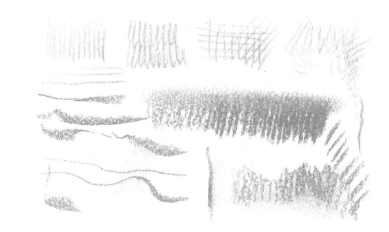

sanguine

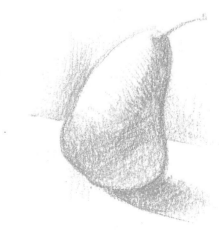

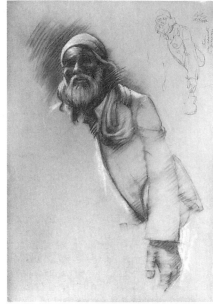

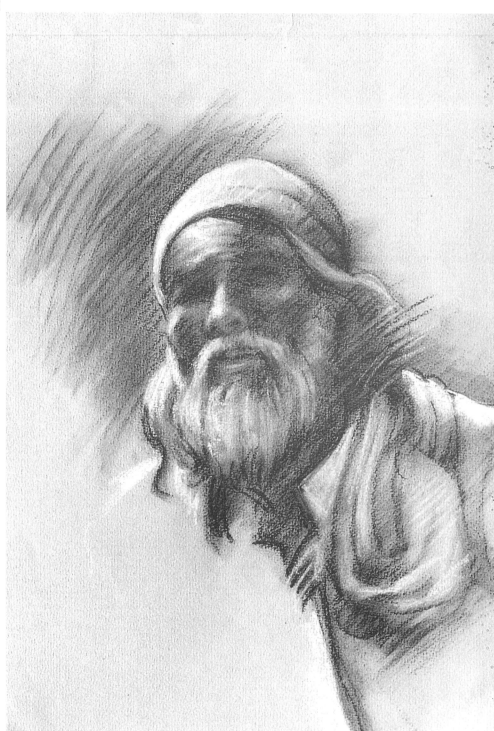

Study in black compressed charcoal, sepia pastel and white pastel on rough grey paper, 50 x 70 cm (19½ x 27½ in). Use the charcoal to highlight the tonal shapes rather than the detail, and exploit the paper's rough texture to achieve expressive and immediate effects.

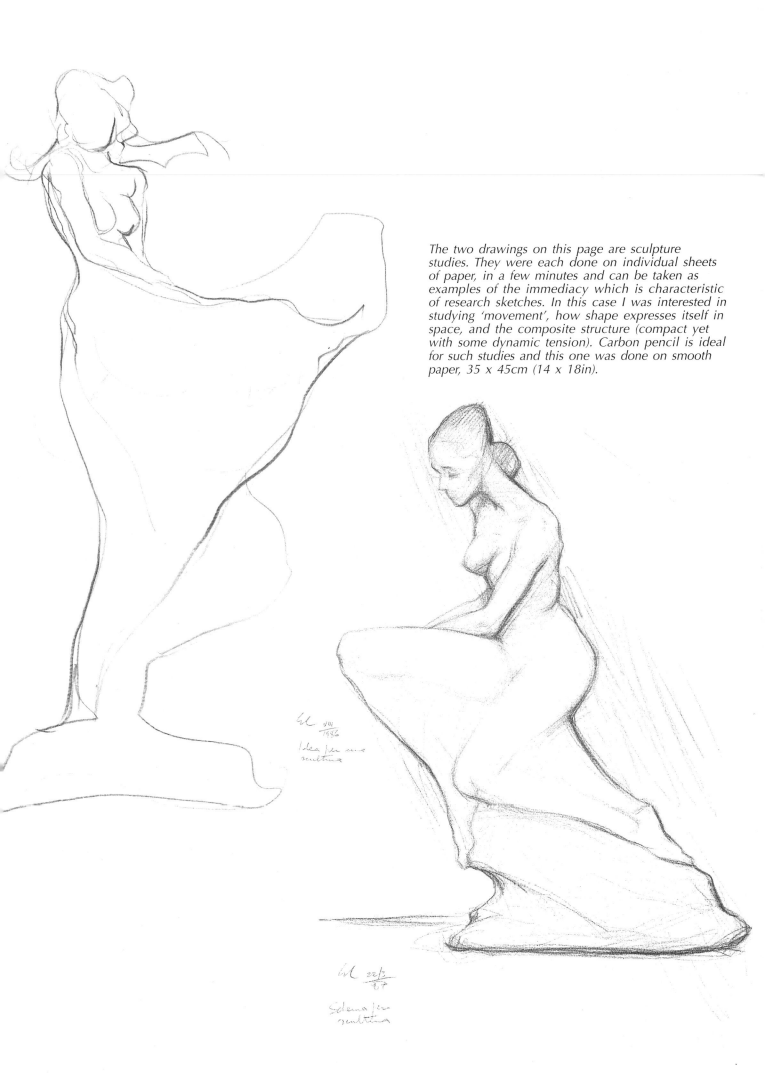

The two drawings on this page are sculpture studies. They were each done on individual sheets of paper, in a few minutes and can be taken as examples of the immediacy which is characteristic of research sketches. In this case I was interested in studying 'movement', how shape expresses itself in space, and the composite structure (compact yet with some dynamic tension). Carbon pencil is ideal for such studies and this one was done on smooth paper, 35 x 45cm (14 x 18in).

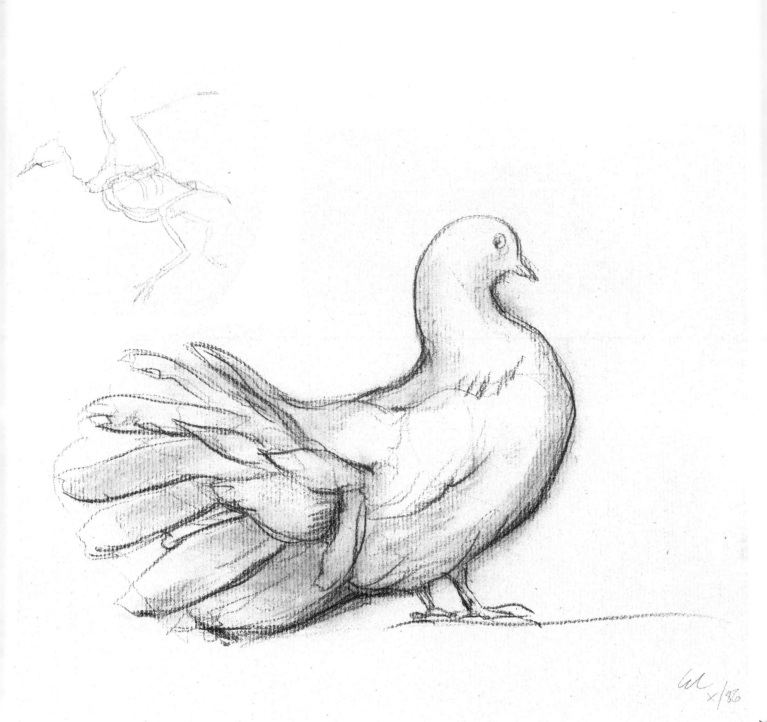

Even a simple sketch, a sort of visual note, can be interesting and expressive. Practise drawing quickly and concisely. First study the subject's shapes and proportions carefully but then be spontaneous and inquiring, and make the drawing an interpretation rather than a pedestrian and formal replica of the model. For this sketch I used sanguine for the medium tones and compressed charcoal for the supporting lines, on rough wrapping paper. For the small sketch above I used a well-sharpened carbon pencil.

Willow charcoal and carbon pencil have been used for this drawing, on smooth paper, 45 x 55cm (18 x 21½in). I drew the outline of the flowers accurately in hard pencil (2H), keeping the pressure light as you can see on the right. I then worked on the chiaroscuro with the charcoal, smudging it with my fingers and some cotton wool. Finally, I adjusted tones and light with a kneadable putty eraser: gently on leaves and flowers, more markedly on the background contours. A few direct touches of carbon pencil have helped give some areas a more definite and sharp look.

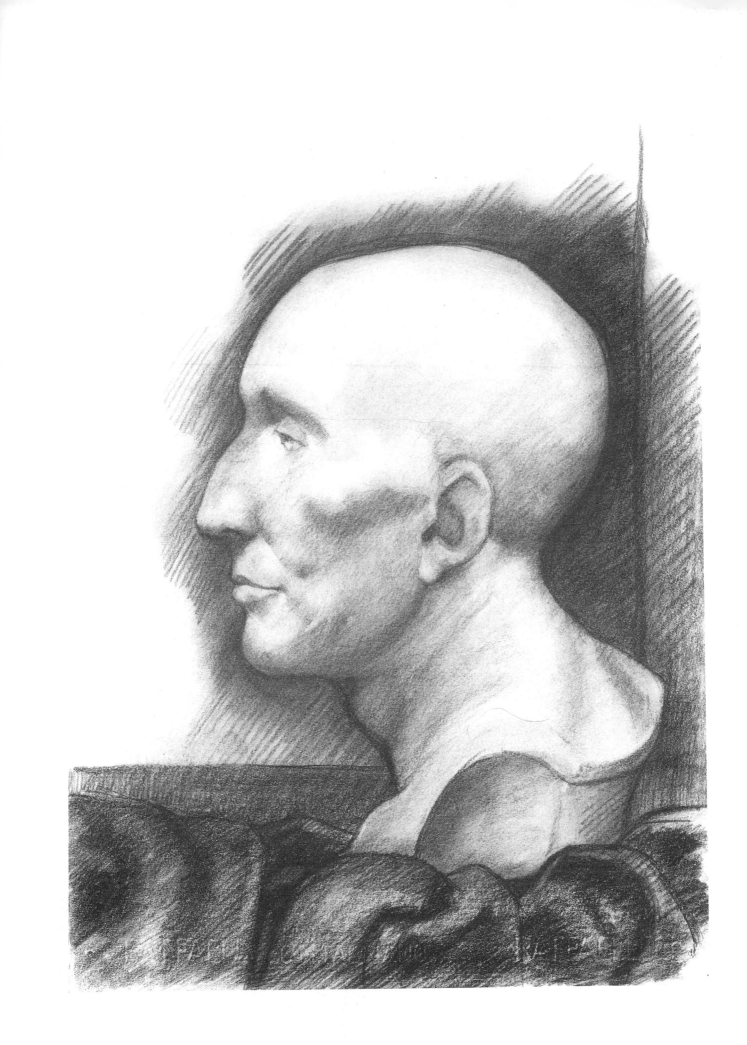

On these two pages you can see the sort of scholastic and academic drawings which used to be (and unfortunately, still are) typical of art schools. I say 'unfortunately' because copying casts and prints offers little stimulation, and does not teach you much. It is certainly better to study the figure from life. This is not always possible, however, and then casts can in part compensate as they allow you to study lights and shadows accurately, without moving. They can therefore, at least at the beginning, provide the opportunity to practise your technique patiently. Each of the three drawings shown here has been rendered on smooth paper, 40 x 50cm (16 x 20in), with willow charcoal and carbon pencil gently smudged with a finger, using a kneadable putty eraser to add highlights.

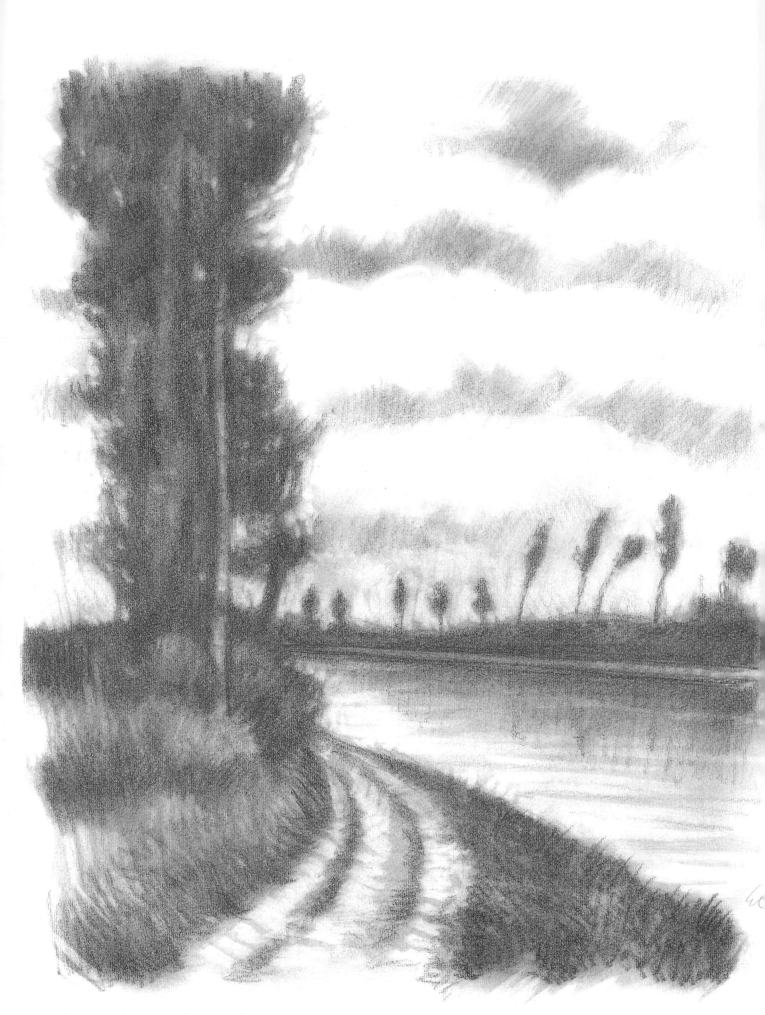

Lombardy Landscape. Carbon pencil on paper, 30 x 40cm (12 x 16in).

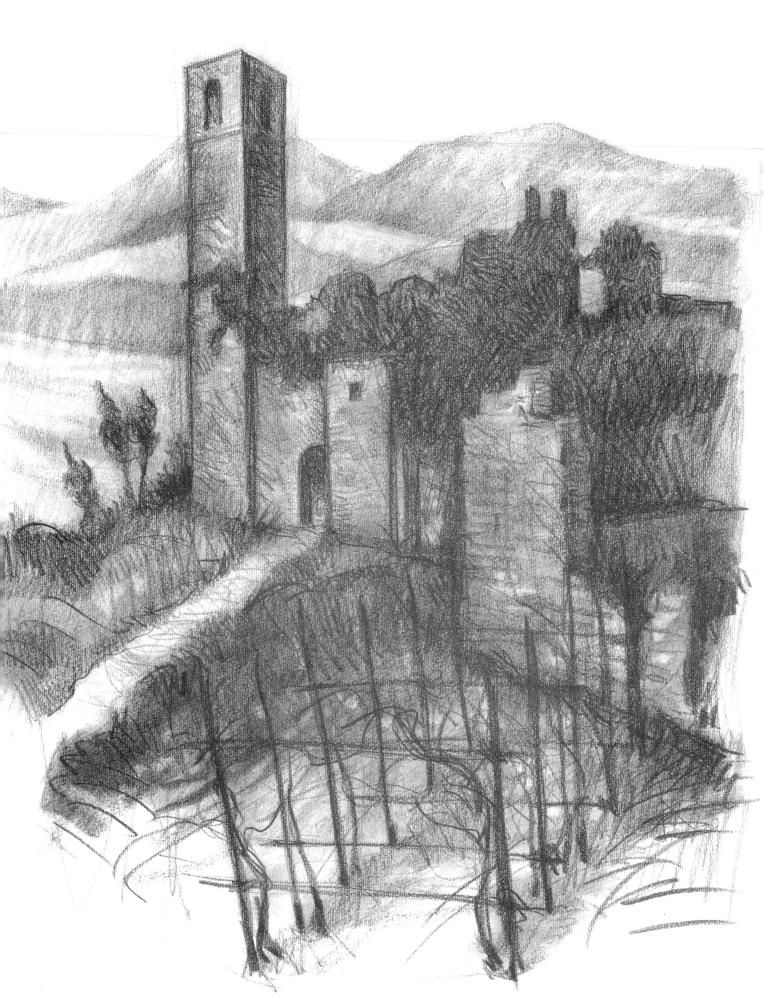

Ruins. Carbon pencil on paper, 30 x 40cm (12 x 16in).

INK

Although Indian ink (black or brown) is most commonly used for drawing, coloured and water-soluble inks, which spread when moistened with the tip of a brush, are also very useful. Ink drawings can be done with a variety of tools: nibs of different shapes and sizes; fountain pens; ballpoint or technical pens; brushes and pointed bamboo reeds. It is better to use fairly heavy, smooth, good-quality paper. Dark tones are created by increasing the density of hatching, cross-hatching or dotting.

EXAMPLES ON MEDIUM-TEXTURED CARD

 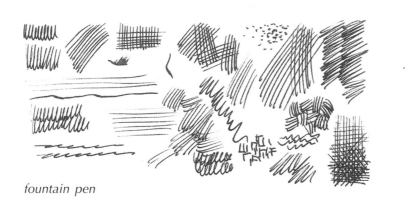

fountain pen

 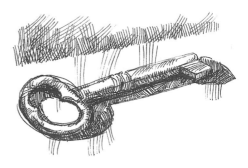

Indian ink and fine nib

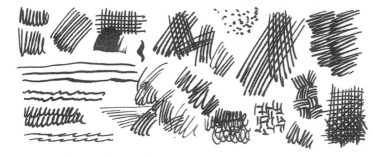 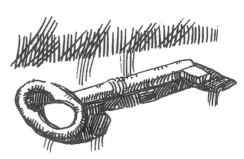

Indian ink and thick nib

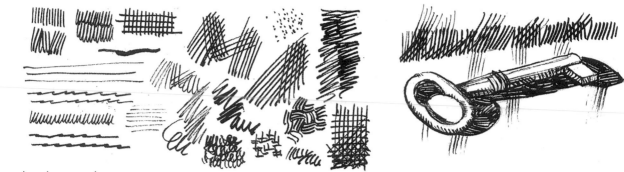

bamboo reed pen

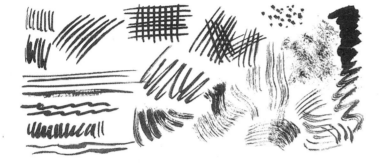

Indian ink and brush

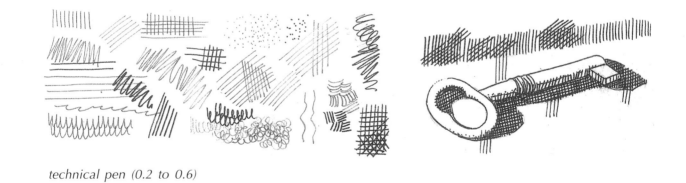

technical pen (0.2 to 0.6)

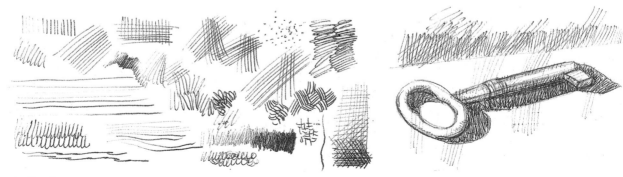

ballpoint pen

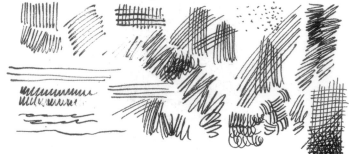

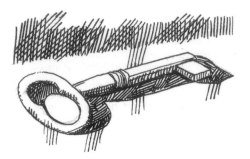

fine-tipped felt pens

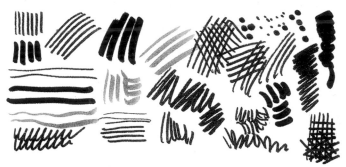

thick-tipped felt pens

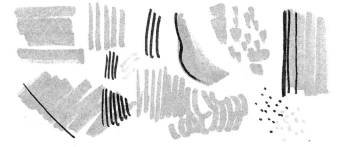

felt pens with chisel-shaped tips and regular felt pens

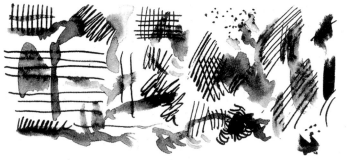

pen, brush and water-soluble ink

I drew this figure on stiff, medium-textured cardboard, 36 x 51cm (14 x 20in), using black Indian ink and a thick nib which allowed for regular and spaced-out hatching and cross-hatching. The body's form is hinted at, rather than described faithfully.

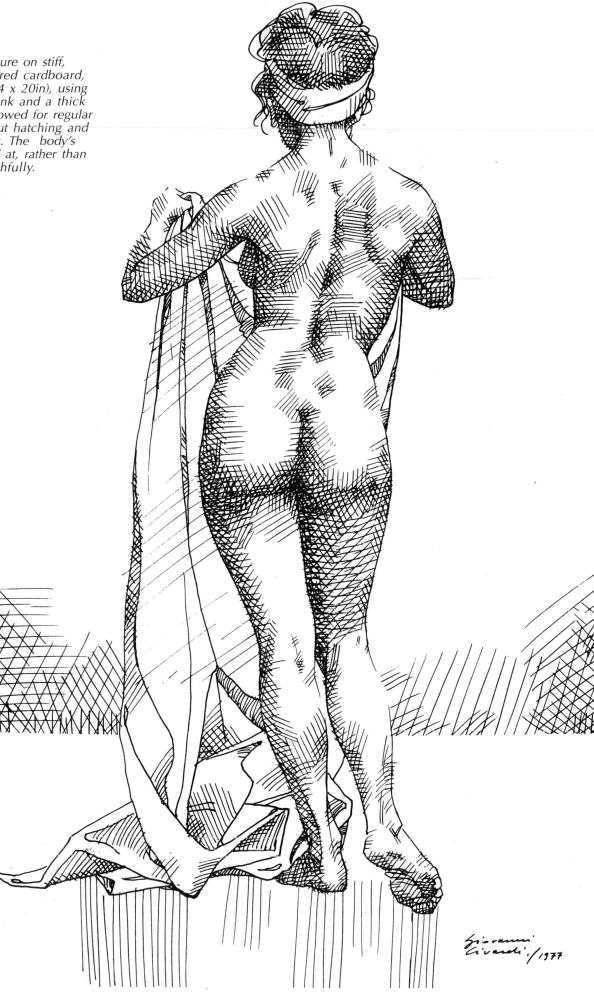

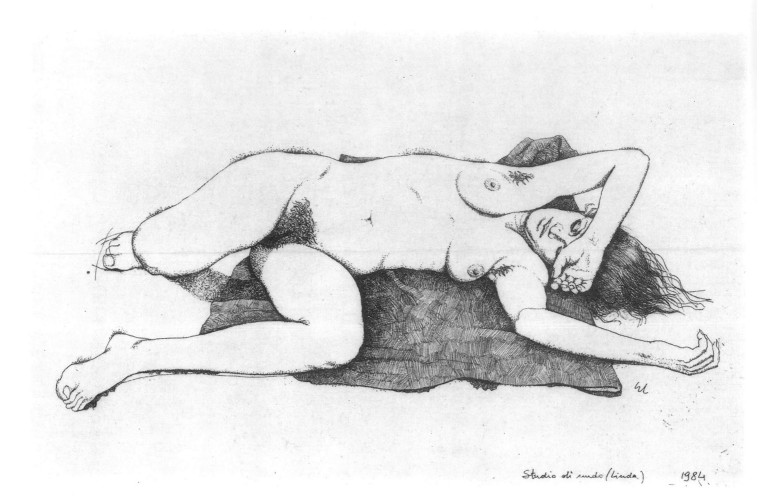

Studio di nudo (Linda) 1984

The figure study shown here, unlike the one on the previous page, has been drawn on smooth cardboard, 18 x 25cm (7 x 10in), using black Indian ink and a very thin nib. I have drawn the cloth and its folds using dense parallel strokes in different directions, while for the body I have used a series of little dots of varying intensity. After finishing the drawing, I erased the faint preliminary pencil lines with a kneadable putty eraser.

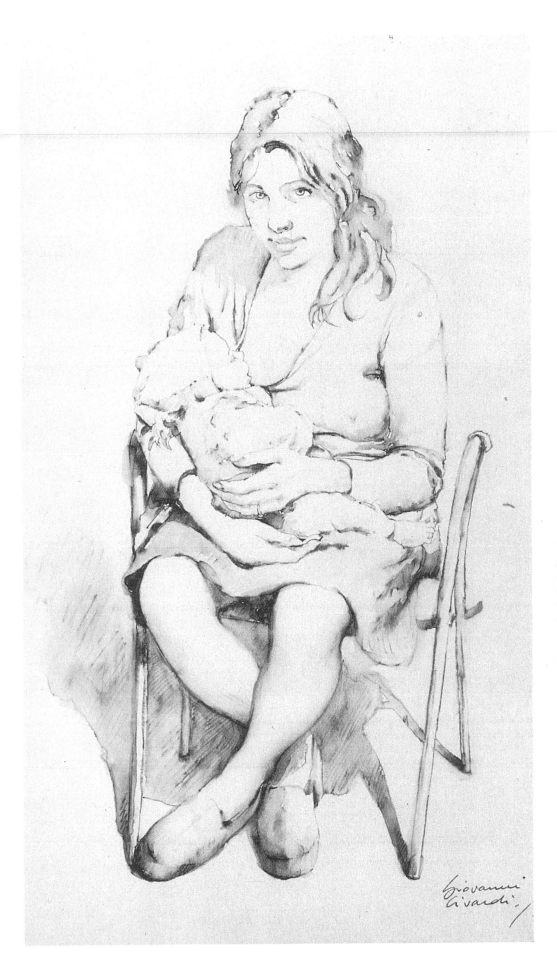

Water-soluble ink is very well suited to quick tonal studies from life. I drew 'Valeria breast-feeding' on stiff medium-textured card, 27 x 45cm (10½ x 18in), with a normal fountain pen filled with black 'Parker' ink. Using a medium-size brush (No. 6 round) I moistened and dissolved the ink in the shaded areas and wherever I wanted a softer stroke. You need to be very careful when doing this, as too much water may make the ink spread excessively and spoil the whole drawing. On the other hand, accidental effects often turn out to be interesting. I would therefore advise you to conduct a few tests to master this simple, yet difficult, technique. You might also like to try water-soluble colour inks. Bear in mind that Indian ink is not suitable for this technique as it is permanent, and strokes do not therefore dissolve in water.

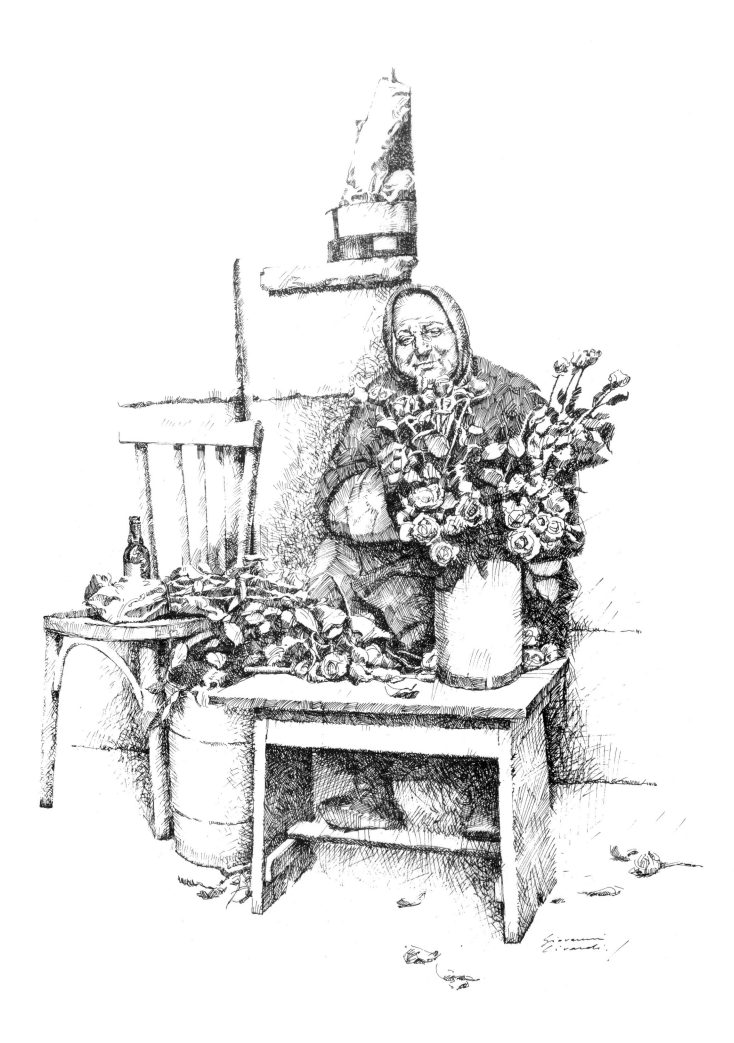

The subject of these two drawings is an elderly flower-seller, very distinctive and well known, many years ago, in the Pantheon district of Rome (where she was often photographed by tourists) and whom I happened to draw from life. Both drawings are on medium-textured card, 36 x 51cm (14 x 20in), with very fine nibs and Indian ink slightly diluted with water to soften its intensity. The fairly irregular, 'loose', yet controlled, hatching, was helped by a light, clear, and precise pencil outline which was erased afterwards.

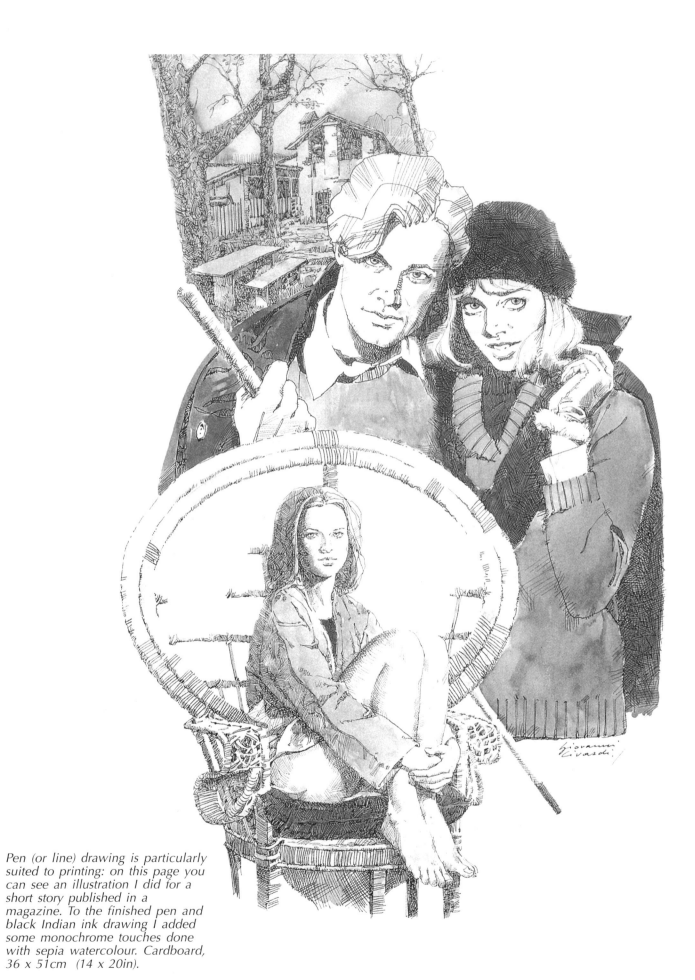

Pen (or line) drawing is particularly
suited to printing: on this page you
can see an illustration I did for a
short story published in a
magazine. To the finished pen and
black Indian ink drawing I added
some monochrome touches done
with sepia watercolour. Cardboard,
36 x 51cm (14 x 20in).

Although the theme of these studies is not exactly cheerful, they were well-suited to a complex pen exercise in preparation for an etching. I used smooth paper, 35 x 35cm (14 x 14in), and black Indian ink with three different nibs: very fine for the drawing on the right; slightly less fine for the one on the left and even less fine for the one below. I adjusted the chiaroscuro by way of short, close hatching, as well as cross-hatching of varying density. Be careful not to scratch the paper with the nib, especially where you want to add the more intense blacks (which should always remain 'transparent' and not thicken to form stains).

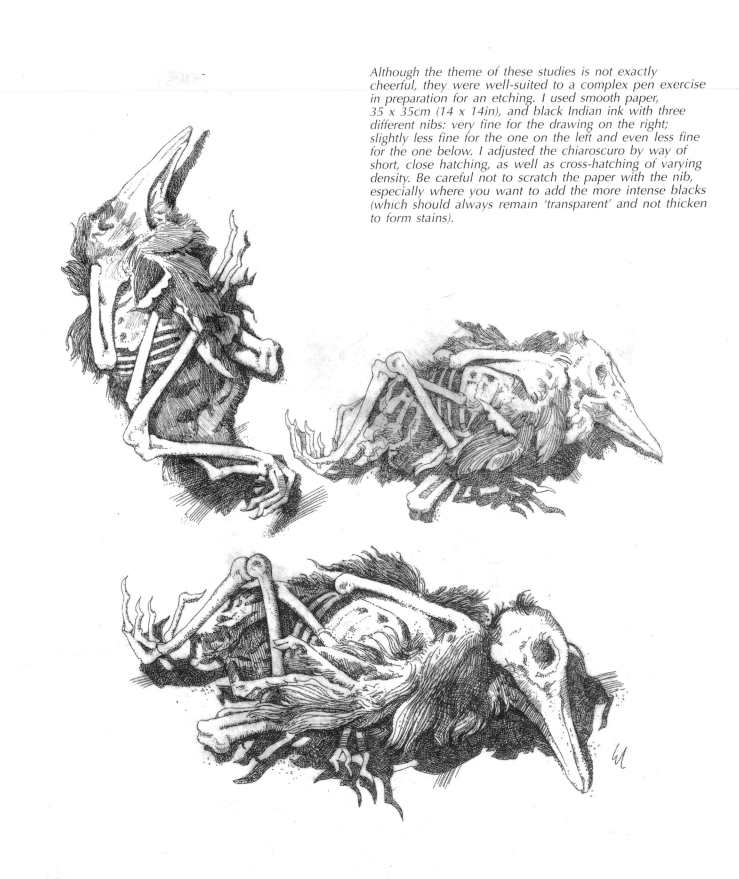

VEXPOS (Cadaverino) VII/1985

Ci sono ricchezze che distruggono se non si possono dividere con gli altri

WATERCOLOUR, TEMPERA AND MIXED MEDIA

'Wet' techniques, in which inks or pigments are diluted with water, are widely used in artistic drawing, although they are not strictly speaking, 'graphic', and achieve a look which is closer to painting. Monochrome watercolours (usually in dark shades such as sienna and sepia) and water-soluble ink have been used for a very long time; when applied with a brush, directly or to complement a pen drawing, they enable you to achieve a wide range of tones and very smooth rendering. Mixed media is the simultaneous and combined use in the same drawing of different media. The examples on the following pages show only some of the many possibilities, and I suggest you experiment to find your own, in sympathy with the aesthetic and expressive results you aim to achieve, and taking advantage of unintentional effects.

EXAMPLES ON MEDIUM-TEXTURED PAPER

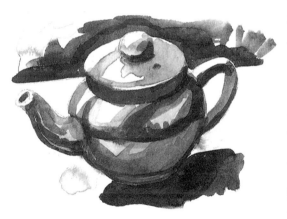

watercolour or water-soluble ink

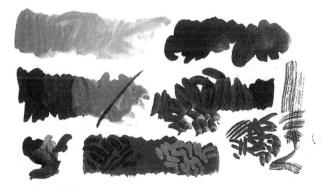
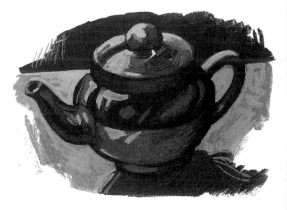

white and black tempera

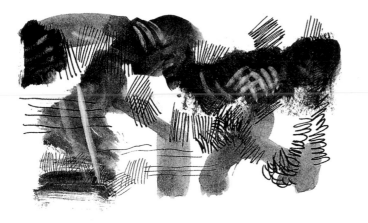
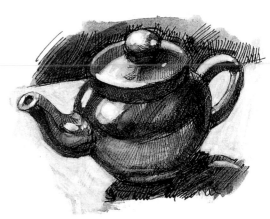

ink, acrylic, white tempera

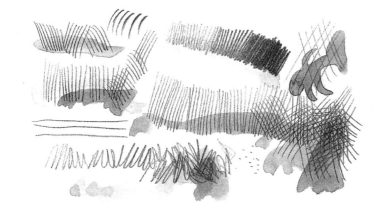

pencil and watercolour (or water-soluble ink)

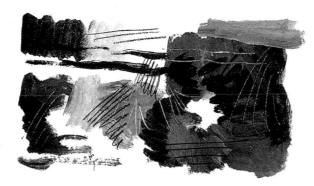
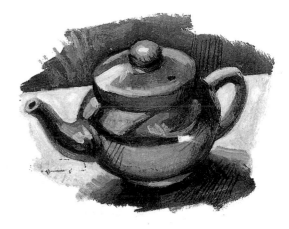

oil and carbon pencil

The examples shown in this section are drawings done with mixed media, i.e. combining different media to achieve particular graphic effects. They are, therefore, slightly removed from the traditional concept of 'drawing', but I have included them here hoping that they will encourage you to experiment.

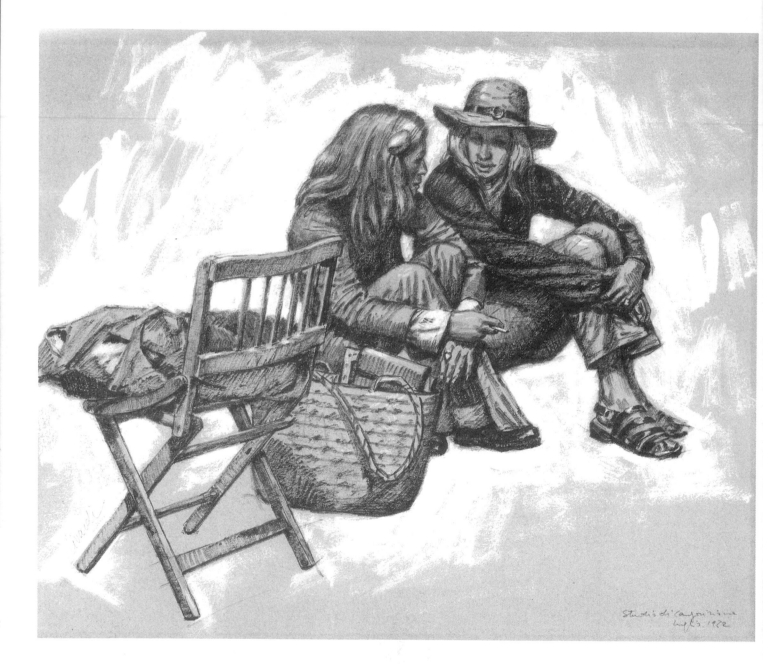

This drawing was done in dry brush (black Indian ink applied with a round bristle brush which had become almost dry by resting it on blotting paper). The background was highlighted and retouched with fairly thick white tempera. Grey card, 35 x 40cm (14 x 16in).

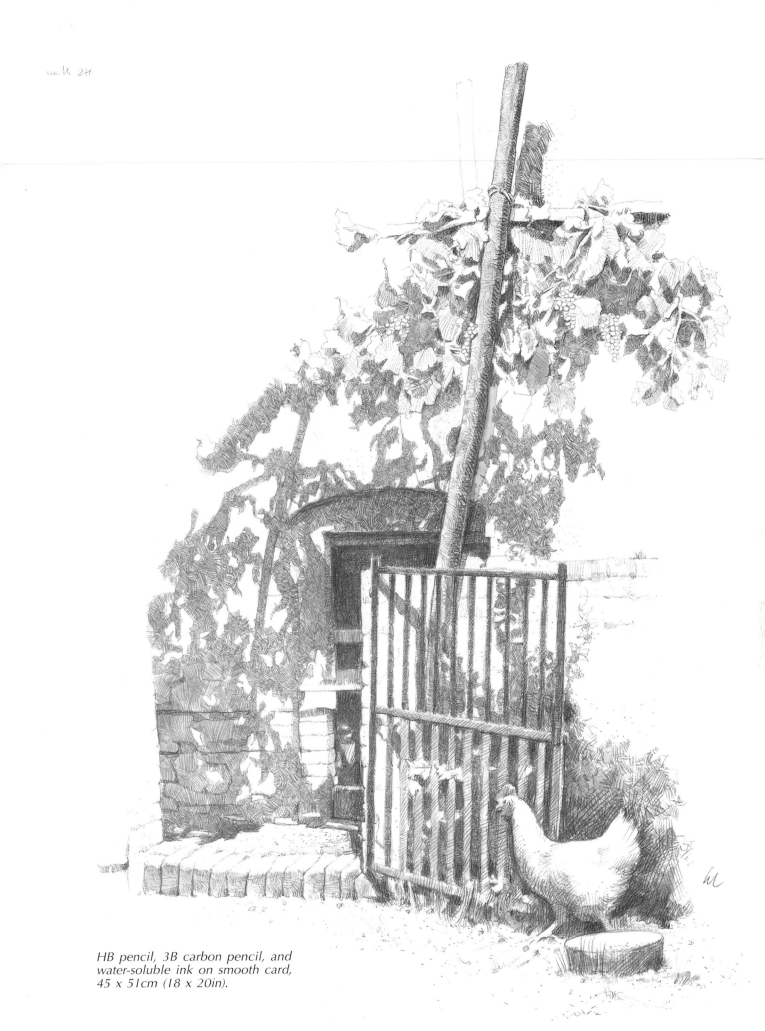

HB pencil, 3B carbon pencil, and water-soluble ink on smooth card, 45 x 51cm (18 x 20in).

*Pen and sepia Indian ink, sepia tempera and white
tempera on stiff cardboard, 35 x 35cm (14 x 14in).*

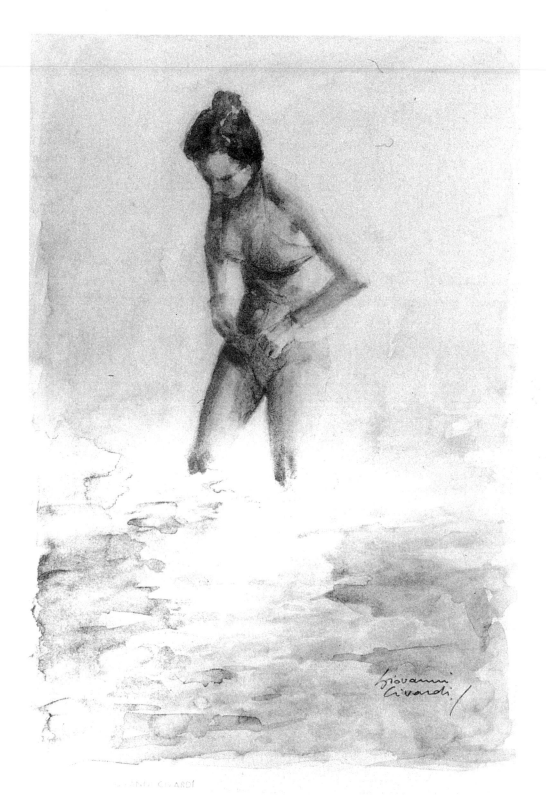

*Water-soluble ink applied with a round No. 6 bristle brush
on medium-textured stiff cardboard, 20 x 30cm (8 x 12in).*

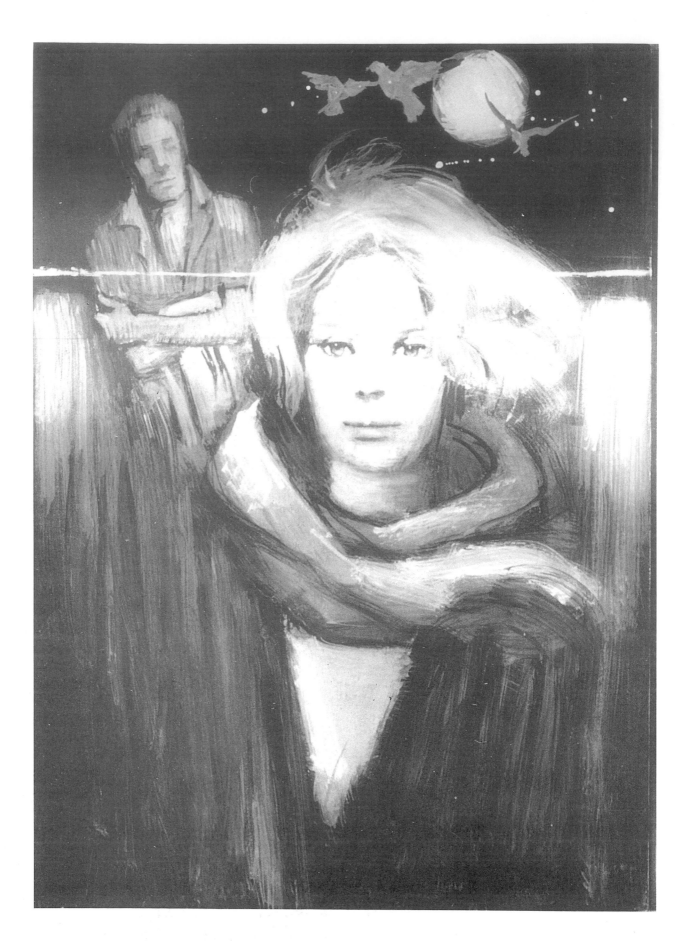

Study for an illustration. White and black tempera, 2B carbon pencil and white pastel on grey-green cardboard, 36 x 51cm (14 x 20in).

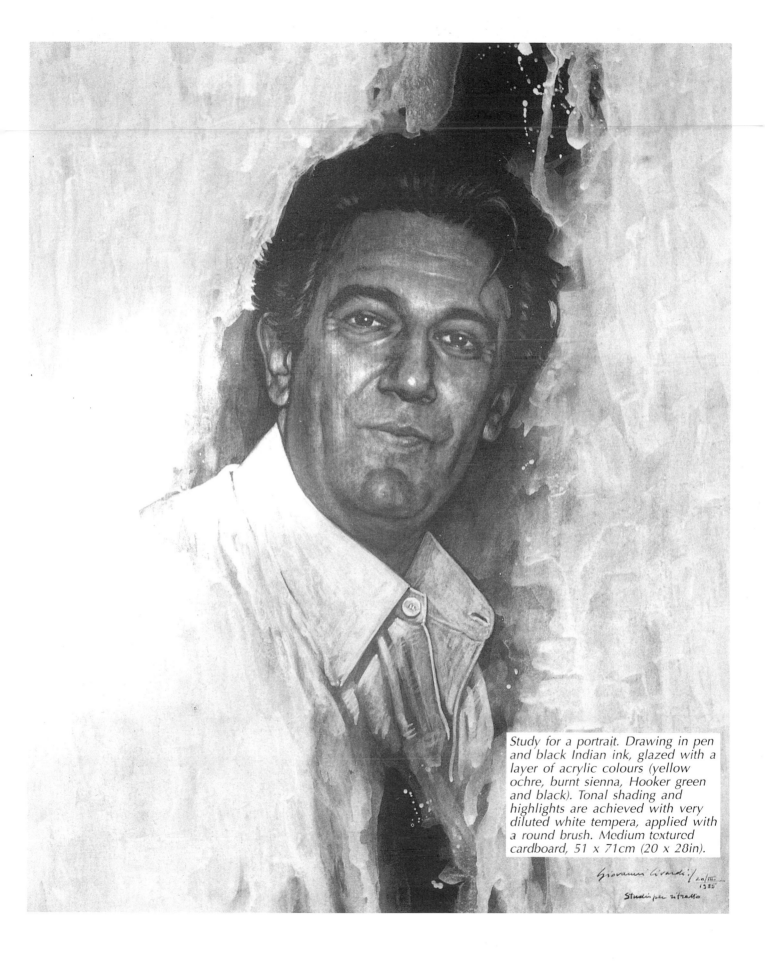

Study for a portrait. Drawing in pen and black Indian ink, glazed with a layer of acrylic colours (yellow ochre, burnt sienna, Hooker green and black). Tonal shading and highlights are achieved with very diluted white tempera, applied with a round brush. Medium textured cardboard, 51 x 71cm (20 x 28in).

Preliminary drawing in pen, tempera and sepia Indian ink on smooth cardboard, 15 x 20cm (6 x 8in). The colour is partially removed with a small damp sponge.

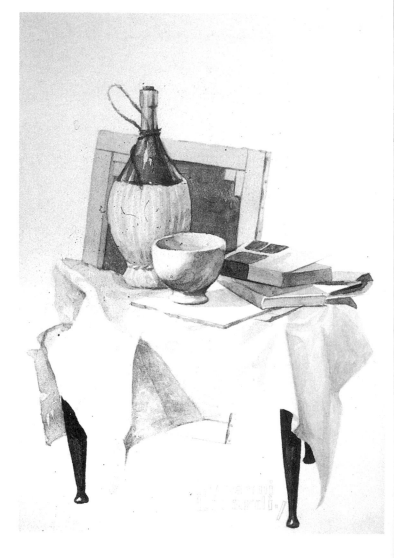

Monochrome grey watercolour applied with a round bristle brush (No. 8) on smooth card, 20 x 25cm (8 x 10in).

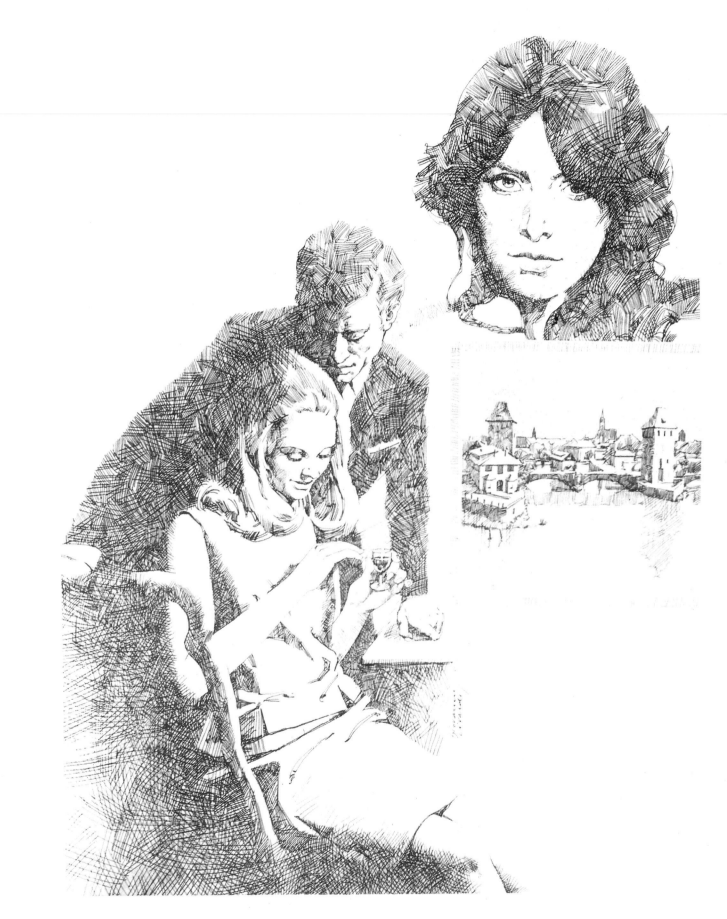

*Illustration, on medium-textured cardboard,
36 x 51cm (14 x 20in). Drawing in pen and sepia
Indian ink, glazed with very dilute Veronese green
acrylic and touched up with white tempera.*

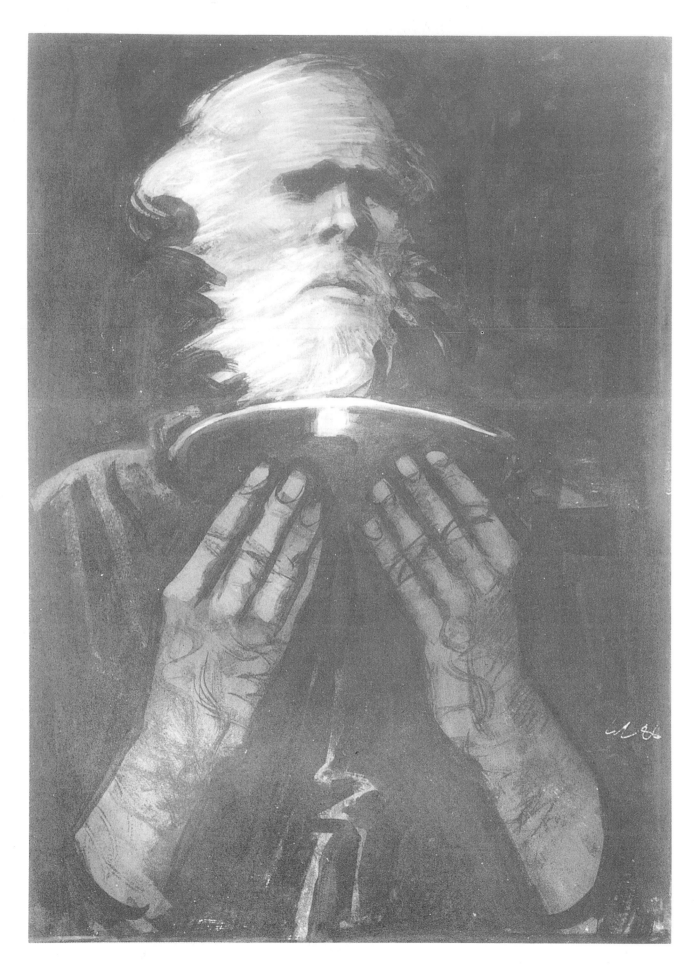

*Study for an illustration. White and black tempera
on grey-green cardboard, 25 x 36cm (10 x 14in).*

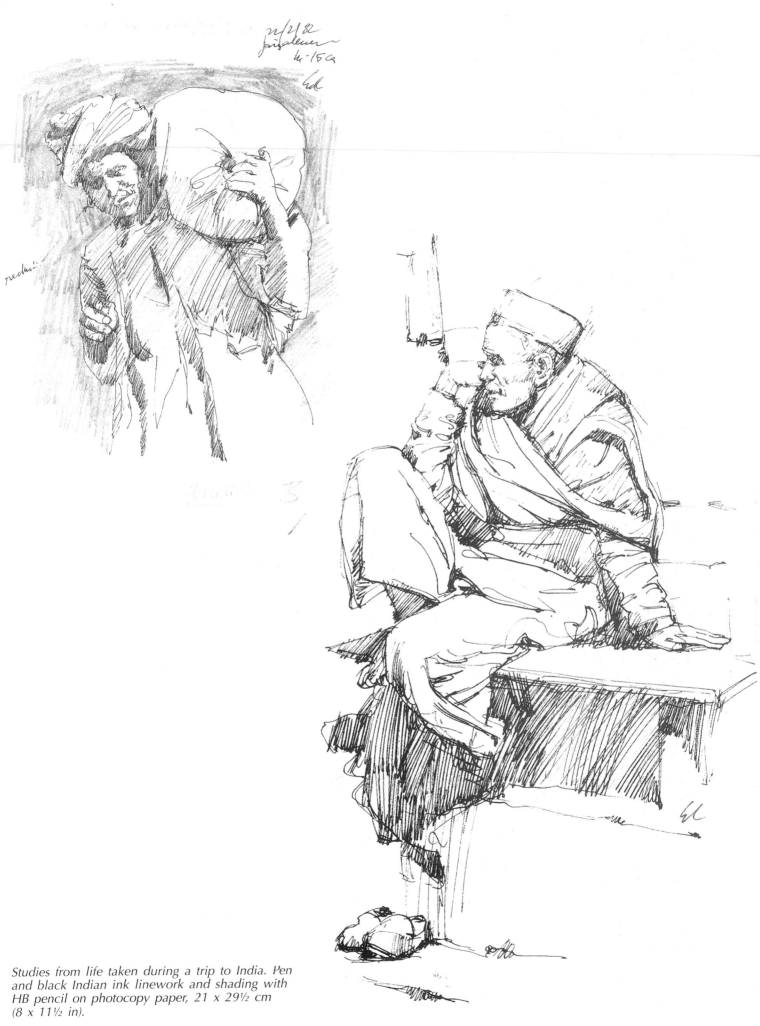

Studies from life taken during a trip to India. Pen and black Indian ink linework and shading with HB pencil on photocopy paper, 21 x 29½ cm (8 x 11½ in).

DRAWING FROM LIFE

To conclude this book I would like to share with you some drawings done by Vittorio Menotti, an engineer and amateur painter, in the early 1900s. They are an example of how the study of drawing was seen a century ago, and compared to today's drawing you can see that methods have not changed much. Drawing from life (landscapes, people, still life) remains the main way of exploring techniques in order to master them, without worrying too much, initially, about aesthetic matters. Of course, tastes have changed: nowadays we appreciate immediate and impetuous drawing, rather than the 'academic' reproduction of reality; however, it is almost always worthwhile to go through this rigid experience before you can achieve a freer and more personal language.

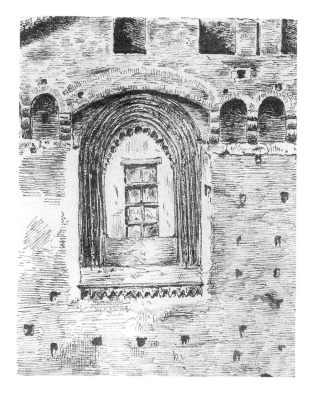

Window of the Sforza Castle, Milan. Pen and sepia ink on paper, 8 x 10cm (3 x 4in).

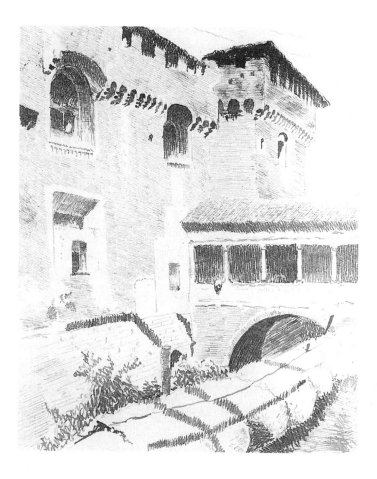

View of the Sforza Castle, Milan. Pen and sepia ink on paper, 9 x 11½ cm (3½ x 4½ in).

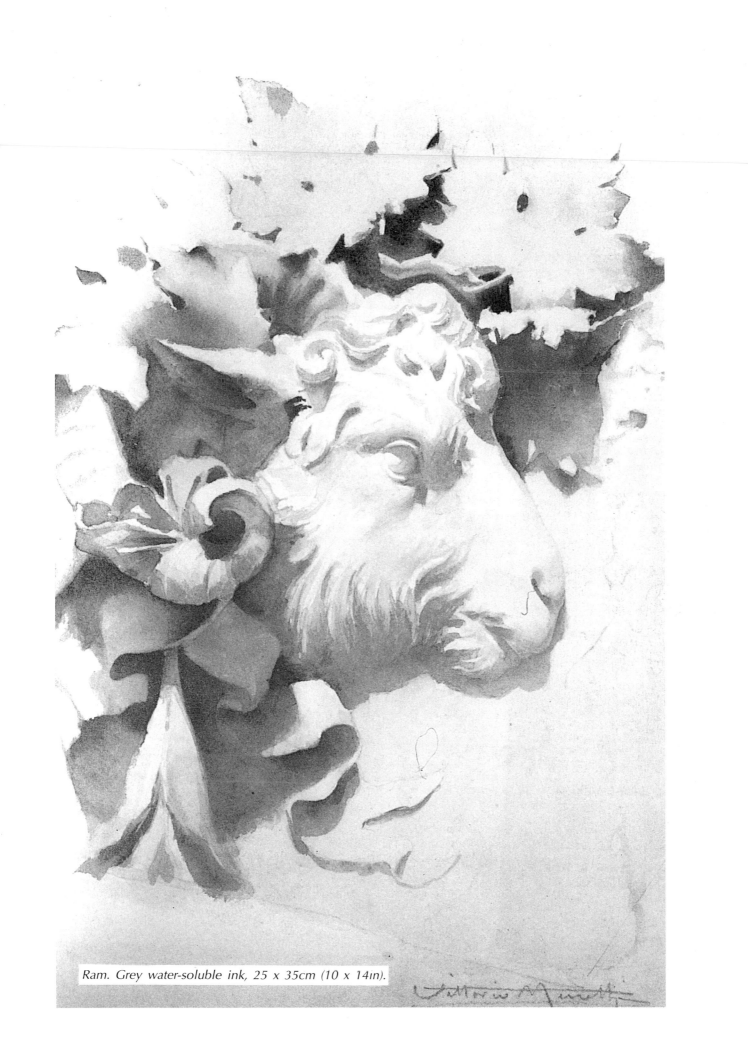

Ram. Grey water-soluble ink, 25 x 35cm (10 x 14in).

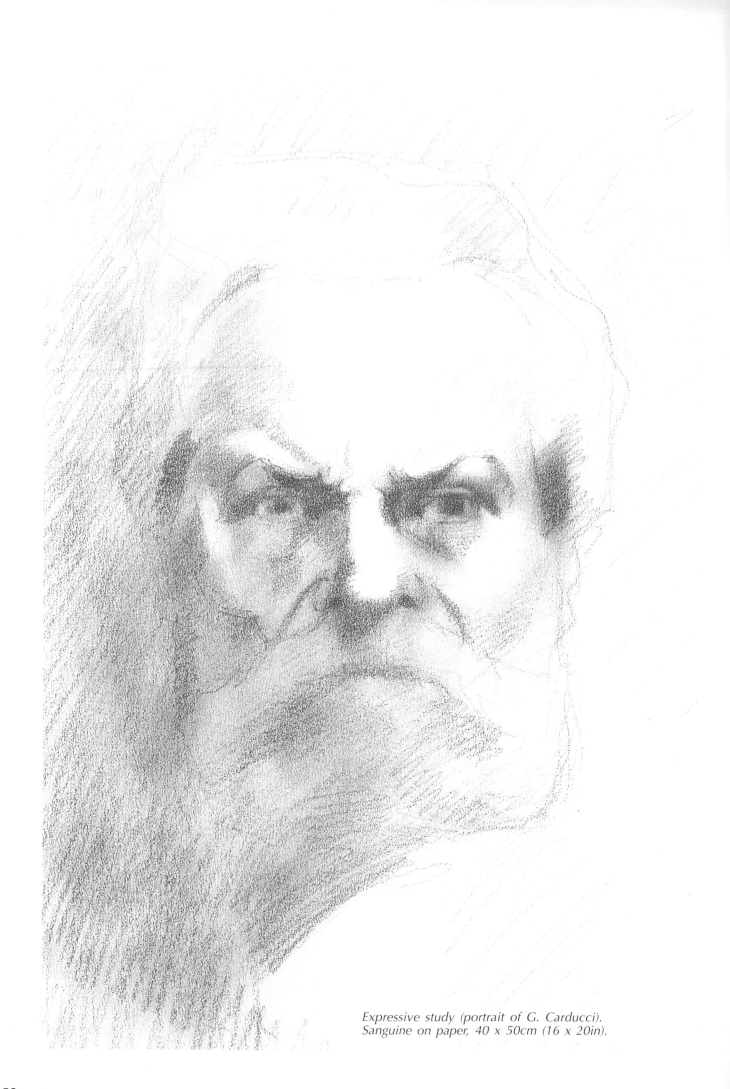

Expressive study (portrait of G. Carducci).
Sanguine on paper, 40 x 50cm (16 x 20in).

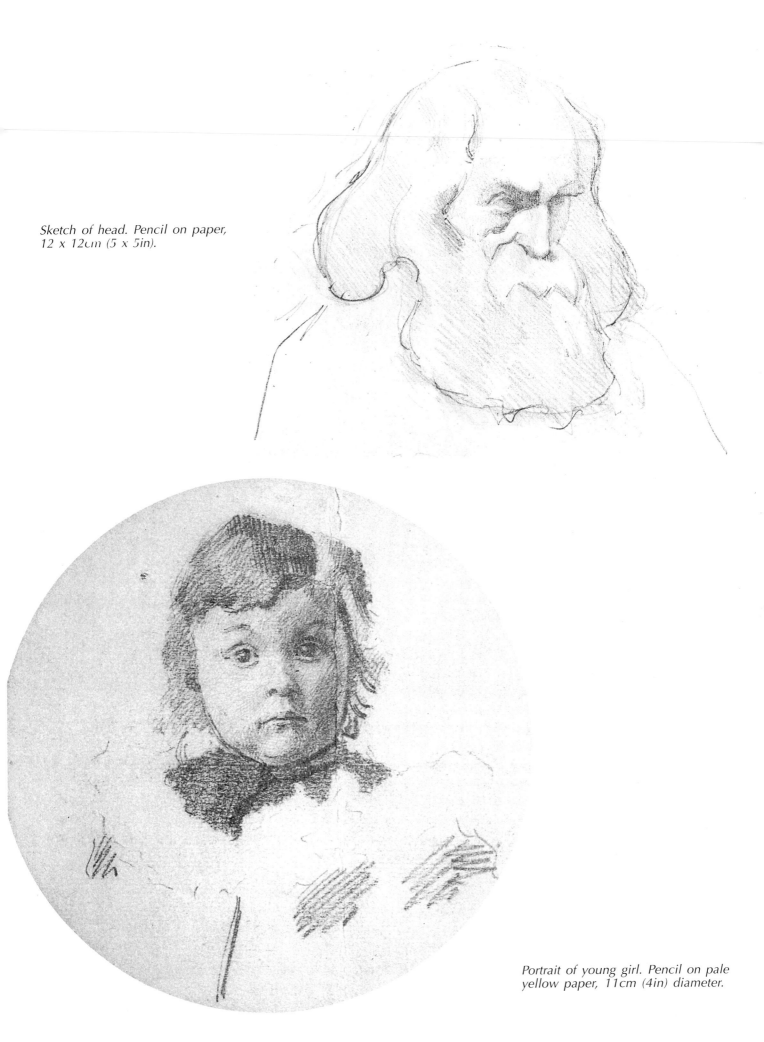

Sketch of head. Pencil on paper, 12 x 12cm (5 x 5in).

Portrait of young girl. Pencil on pale yellow paper, 11cm (4in) diameter.

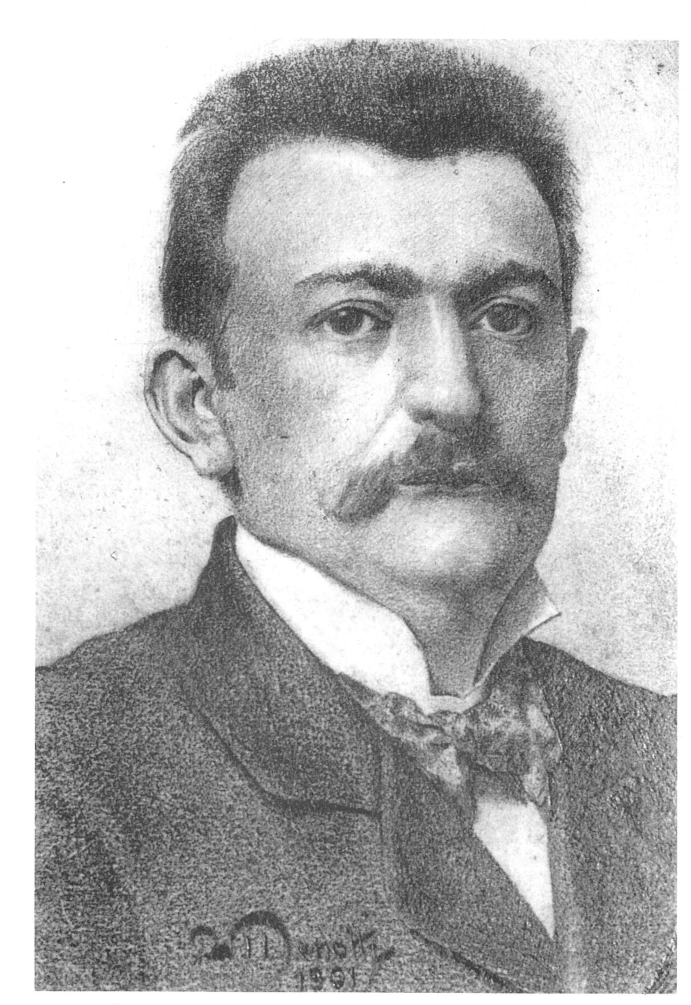

Portrait. Pencil, charcoal and highlights in white
pastel on grey paper, 11 x 15cm (4 x 6in).

3 - 9be 1902.

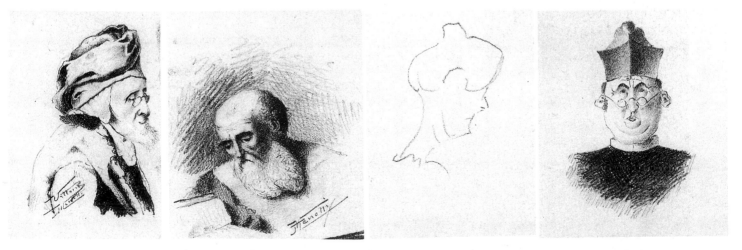

Studies of expressive heads.
Always carry a little sketchpad on which to make
visual notes and which will teach you to 'see' and
become aware of the 'graphic' aspects of reality.

PRACTICAL ADVICE

LIGHTING

The quality of lighting and the surface on which one draws are very important for working comfortably. Studio lighting must be bright enough not to tire one's eyes, come from just one source (a window, if daylight, or a lamp if artificial) and its position must be such that it doesn't create ugly shadows on the page. When outdoors, avoid direct sunlight as this alters tonal relationships.

SUPPORTING YOUR DRAWING

The drawing surface can be vertical, e.g. an easel, as this position reduces perspective distortion, and is suitable for drawing on a large-size sheet and studying the figure from life. More often you will work on tables of varying inclination. In both cases it is useful to have a seat set at the correct height to allow you to draw comfortably and, above all, to avoid incorrect positions which can be damaging to the body. Avoid, wherever possible, horizontal tables.

To draw from life outdoors, you will need a stiff folder or a small board to rest on your knees. If you use a sketchbook, you won't need any other support, otherwise you can fasten a sheet on to the board with some masking tape or pins. MDF, with its smooth surface, provides good support, but make sure you place a few sheets between it and your drawing paper (especially if you are using a pencil) to make the strokes less hard.

PAPER

Try various types of paper: smooth, rough, textured, coloured, of different thickness and weight. Pencil, especially if soft, and charcoal require rather rough and stiff paper; pens flow more easily on smooth non-absorbent paper; mixed media and diluted ink work better on fairly stiff card. Always choose the best quality paper you can afford as the mediocre or poor-quality type may indeed free you from the inhibition one feels when faced with a blank sheet (whereby we don't care if we waste it as it is cheap) but almost invariably yields disappointing results.

For little sketches or composition studies you can use run-of-the-mill photocopy paper. However, what I said doesn't mean that you can't draw good sketches on wrapping paper or newsprint.

HOLDING A PENCIL

The way you hold the pencil (whether you are right- or left-handed) is strictly personal. The usual way to hold it is as if you were writing, but when drawing you should bear in mind a few things: hold the pencil (or pen, or brush) with your fingers not too close to the tip, at least 2½ cm (1in) from it, so that you control it well, both manually and visually; do not hold it too tight to avoid getting tired; when drawing it should be your wrist that moves, rather than just your fingers and it should be in a decisive motion; vary not just the pressure but also the angle of the pencil on the paper to achieve different degrees of thickness and stroke variation.

The usual position is comfortable only when drawing on a tilted plane but becomes difficult to maintain if the sheet you are working on is in a vertical position. In this case, especially with charcoal, the drawing tool can be kept in the hand, arm almost stretched, in a movement embracing the whole limb. You'll soon master these positions as they come fairly naturally; however, practise them in order to assume the correct pose from the start.

DRAWING WITH PENCIL

Pencils can be sharpened mechanically with an appropriate sharpener (besides the conventional blade sharpeners, table, hand-held or electrical types are also available), but the best way is to use a sharp knife to make a gradual taper to the lead giving it a long or short point. While a long point is fine for hard grade graphite, the soft grade type breaks easily even with light pressure and must, therefore, be supported by the surrounding wood. With a little practice you will learn to cut away the wood correctly. You can make the points of all types of graphites and

charcoal very sharp by rubbing and rolling them on a strip of fine sandpaper. Very thin leads don't need sharpening.

A trick to avoid smearing the surface on which you are drawing on in pencil or ink, is to protect it by placing a sheet of tracing paper under the hand you are using.

Use erasers as little as possible because even the softest is abrasive and damages the paper's surface. Use them, instead, to draw, i.e. to lighten tones, to outline contours and highlights, or to hatch an area in pencil or charcoal.

DRAWING WITH CHARCOAL

Both willow and compressed charcoal are rather crumbly and leave dusty tracks on the drawing surface. To get rid of excess coaldust you just need to blow on it, but you can also keep the sheet vertical so that your hand won't accidentally touch it causing the dust to fall. When you have finished working you can remove charcoal or graphite residues with a kneadable putty eraser, taking care not to erase too hard but, rather, blotting gently.

Protect soft graphite and, especially, charcoal drawings by applying repeated, even layers of fixative. Cans which spray evenly and reliably are available. Keep the drawing vertical, and hold the can 30-40cm (12-16in) away and spray first vertical then horizontal bands, rather quickly, without stopping or lingering to avoid bright halos. If you want to fix large drawings or technical studies, you can use conventional hairspray, which is cheaper and reasonably effective. When spraying the fixative make sure there are no objects close by which could be damaged by the lacquer. It is best to do the job in a sheltered corner outdoors to avoid breathing in the fumes.

DRAWING WITH INK

When using pen and ink first draw a rough and very light pencil sketch with a hint of hatching. This will help you when you go over it with Indian ink but it should not constrict you to the point of making the drawing even, almost mechanical, and lacking in freshness. Pencil strokes can be deleted with a kneadable putty eraser when the work is completed, making sure the ink is dry first. Practise drawing with a pen straight away, without worrying too much about possible inaccuracies, as only by doing this will you achieve the spontaneity, the confident strokes and the immediacy which characterize this technique.

Pens, which should be kept tilted at about 45°, flow easily on smooth paper, while they catch on a rough surface. However, you can draw on rough surfaces using nibs with a thick, slightly rounded point or bamboo reeds. Unless you are trying to achieve frayed effects avoid any absorbent papers as they make working with pens difficult.

Bear in mind that ink (especially Indian ink) will become concentrated and more difficult to use if its container is left open as its water component evaporates. To offset this, add, every now and then one or two drops of water, preferably distilled, making sure that these additions do not make the ink too light.

Clean nibs thoroughly and frequently while working, getting rid of ink deposits with a damp cloth: don't use paper as it will leave filaments which may make the stroke less sharp. Any unwanted stains or smears can be removed with a blade kept perpendicular to the sheet, or with an appropriate eraser, paying attention not to damage the paper. Alternatively, you can hide them with white tempera or typist's correction fluid.

Dublin City Public Libraries